*Essential Skills*

# location photography

mark galer

Focal Press

OXFORD   AUCKLAND   BOSTON   JOHANNESBURG   MELBOURNE   NEW DELHI

Focal Press
An imprint of Butterworth-Heinemann
Linacre House, Jordan Hill, Oxford OX2 8DP
225 Wildwood Avenue, Woburn, MA 01801-2041
A division of Reed Educational and Professional Publishing Ltd

A member of the Reed Elsevier plc group

First published 1999

**British Library Cataloguing in Publication Data**
A catalogue record for this book is available from the British Library

**Library of Congress Cataloguing in Publication Data**
A catalogue record for this book is available from the Library of Congress

ISBN 0 240 51548 X

Printed and bound in Great Britain

FOR EVERY TITLE THAT WE PUBLISH, BUTTERWORTH-HEINEMANN
WILL PAY FOR BTCV TO PLANT AND CARE FOR A TREE.

raphy

# Acknowledgements

Among the many people who helped make this book possible, I wish to express my gratitude to the following individuals:

Professor Robin Williams and Michael Wennrich for their strong support for the project.
Sandra Irvine, John Child and Dorothy Connop for advice and input to the final copy.
The students of RMIT University and Photography Studies College, Melbourne, for their illustrative input and friendship.
Above all I am eternally grateful for the love, support and understanding of my wife Dorothy and for our two children Matthew and Teagan.

# Picture Credits

# Contents

# Introduction

Location photography covers a wide range of disciplines. From the captured image of a fleeting moment using existing light to the highly structured and preconceived advertising image using introduced lighting. This book is intended for students of photography working on location using primarily the existing light source. The information, activities and assignments provide the essential techniques for creative and competent location photography. The subject guides offer a comprehensive and highly structured learning approach, giving support and guidance to both staff and students. Basic theoretical information is included along with practical advice gathered from numerous professional photographers. An emphasis on useful (essential) practical advice maximises the opportunities for creative photography.

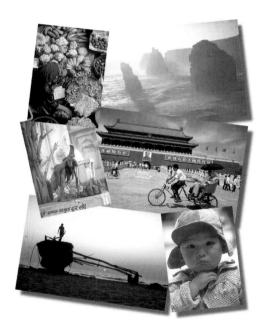

## Acquisition of technique

The first half of the book concentrates on the acquisition of skills necessary for location photography. Emphasis is placed on image design, communication of content and the essential techniques required for competent and consistent image capture and creation. The book builds student competence to correctly expose film under difficult lighting conditions. The practical problems of contrast are discussed and additional lighting in the form of flash is introduced. Terminology is kept as simple as possible using only those terms in common usage by practising professionals.

## Application of technique

The second half of the book is devoted to the practical application of student skills. A historical context is given for two of the major areas of location work (photo-essay and landscape). The difference between capturing and creating images is discussed along with the appropriate application of each commercial working style. The last chapter deals with the subject of working under art direction to specific commercial guidelines. Assignments are undertaken in each of the four areas allowing students to express themselves and their ideas through the appropriate application of design and technique.

# Introduction to teachers

This book is intended as an introduction to location photography for full-time students of photography and/or design. The emphasis has been placed upon a practical approach to the subject and the application of the essential skills. The activities and assignments cover a broad range of skills but avoid the need for the students to use large amounts of expensive equipment on location.

## A structured learning approach

The photographic study guides contained in this book offer a structured learning approach that will give students a framework for working on photographic assignments and the essential skills for personal communication.

The study guides are intended as an independent learning resource to help build design skills, including the ability to research, plan and execute work in a systematic manner. The students are encouraged to adopt a thematic approach, recording all research and activities in the form of a visual diary.

## Flexibility and motivation

The study guides contain a degree of flexibility often giving students the choice of subject matter. This allows the student to pursue individual interests whilst still directing their work towards answering specific criteria. This approach gives the student maximum opportunity to develop self-motivation. It is envisaged that staff will introduce each assignment and negotiate the suitability of subject matter with the students. Individual student progress should be monitored through group meetings and personal tutorials.

Students should be encouraged to demonstrate the skills which they have learnt in preceding study guides whenever appropriate.

## Implementation of the curriculum

For students studying photography full time the complete curriculum contained in this book would cover the first semester of the first year. If the curriculum contained in this book is combined with "Studio photography" (also available in the series) this would constitute the majority of the first-year practical curriculum.

# Introduction to students

The study guides that you will be given on this course are designed to help you learn both the technical and creative aspects of photography. The first three study guides provide the framework for the assignment briefs that follow. The study guides will build the essential skills required to confidently undertake a broad range of location work.

## Activities and assignments

By completing all the activities and assignments in each of the study guides you will learn how other images were created or captured and how to communicate visually utilising your own camera as a tool. You will be given the freedom to choose the subject of your photographs in many of the assignments. The images that you produce will be a means of expressing your ideas and recording your observations.

Photography is a process that can be learnt as a series of steps. Once you apply these steps to new assignments you will learn how to be creative with your camera and produce effective images. The information and experience that you gain from the study guides will provide you with a framework for all of your future location work.

## Using the study guides

The study guides have been designed to offer you support during your photography work. On the first page of each study guide is a list of aims and objectives laying out the skills covered and how they can be achieved.

The activities are to be started only after you have first read and understood the supporting section on the same page. If at any time you feel unclear about what is being asked of you, **consult a lecturer**.

## The skills

To acquire the essential skills required to become a photographer takes time and motivation. The skills covered should be practised repeatedly so that they become practical working knowledge rather than just basic understanding. Practice the skills obtained in one study guide and apply them to each following guide where appropriate. Eventually the technical and creative skills can be applied intuitively or instinctively and you will be able to communicate clearly and effectively.

# Research and resources

The way to get the best out of each assignment is to use the activities contained in the study guides as a starting point for your research.

You will only realise your full creative potential by looking at a variety of images from different sources. Creative artists and designers find inspiration for their work in different ways, but most find that they are influenced by other work they have seen and admired.

## Getting started

Start by collecting and photocopying images that are relevant to the activity you have been asked to complete. This collection of images will act as a valuable resource for your future work.  By taking different elements from these different images, e.g. the lighting technique from one and the design from another, you are not copying somebody else's work but using them as inspiration for your own creation.

Talking through ideas with other students, friends, members of your family and with a lecturer will help you to clarify your thinking, and develop your ideas further.

## Choosing resources

When you are looking for images that will help you with your research activities try to be very selective, using high quality sources.  Not all photographs that are printed are necessarily well designed or appropriate to use.  Good sources of photography may include high quality magazines and journals, photographic books and photography exhibitions.  You may have to try many libraries to find appropriate material or borrow used magazines from friends and relatives. Keep an eye on the local press to find out what exhibitions are coming to your local galleries.

# Visual Diary

A Visual Diary is a record of all visual and written stimulus that may have influenced you or formed the basis of an idea for the photographic assignments. These assignments form the major practical work to be completed.

In its most basic form this could be a scrapbook full of tear sheets (examples) and personal scribbles. It would however be of far more value if the Visual Diary contained additional detail relating to an awareness of a visual development in your ability to comprehend good from bad images. This should include design, composition, form and light applicable to any visual art form.

**The Visual Diary should contain:**
- ~ A collection of work by photographers, artists, writers and filmmakers relevant to your photographic studies.
- ~ Sketches of ideas for photographs.
- ~ A collection of images that illustrate specific lighting and camera techniques relevant to location photography.
- ~ Brief written notes supporting each entry in the diary.

# Presentation of work
## Research

In each assignment provide evidence in your visual diary of how you developed your ideas and perfected the techniques you have been using. This should be presented neatly and in an organised way so that somebody assessing your work can easily see the creative and technical development of the finished piece of work.

Make brief comments about images that you have been looking at and how they have influenced your own work. Photocopy these and include them with your research.

## Finished work

Presentation of work can influence your final mark. Design does not finish when the film is processed. Try laying out the work on your card before sticking it down. If using 35mm film ensure transparencies are slide mounted. If working with a larger format window, mount transparencies in black card. Make sure the window you cut has square corners and is cut with a very sharp blade. Nothing looks worse than a well exposed transparency mounted in a window with ragged edges. Write your name and project title on the back of your work so that it can be returned to you after assessment.

# Storage of work

Assignment work should be kept clean and dry, preferably using a folder slightly larger than your mounted work. It is recommended that you standardise your final portfolio so that it has an overall 'look' and style. Negatives and transparencies should always be stored in file sheets in a dust and moisture-free environment.

# Choice of equipment

The 35mm SLR is the popular choice for most photographers working on location. It is compact, light and quick to use. With built-in through-the-lens metering (TTL) and the ability to change lenses it is extremely versatile.

Medium format cameras are also used professionally on location. With the increased bulk, weight and cost of the equipment the photographer must decide whether to choose superior quality or convenience and speed of operation.

Additional lenses and camera accessories should be purchased through actual, rather than perceived, need. Autofocus zoom lenses, motor-drives and programme modes are expensive extras if you never use them. Many photographers find it more useful to budget for two 35mm camera bodies of the same make rather than one very expensive one. In this way the photographer is able to load each body with a different film giving increased working flexibility and back-up in case of mechanical failure. It is important that the lenses are interchangeable with both bodies. When selecting a medium format camera the photographer should consider a model which has removable film backs to reduce the outlay of a second camera body.

*The 35mm SLR*

Many photographers prefer to travel and work light, others prefer to take every piece of equipment they might need to meet any unforeseen circumstance. If the amount of equipment is kept to a minimum it follows that the bag required to carry it in will also be small. This is of great value when photographing in crowded markets, squeezing onto packed buses and working in confined interior locations. A soft case is nearly always preferable in these situations, allowing you to move through crowds with the minimum of fuss, thus avoiding the situations where a hard case is reluctant to follow or takes chunks out of the furniture on the way through.

# Equipment

Photographers individual requirements for equipment vary enormously. This list is intended as a guide only to the equipment commonly used by many photographers.

Many photographers start with a single 35mm body with one zoom lens. Subsequent purchases usually include additional lenses. It is possible to cover an enormous range of focal lengths with only two lenses. The drawback of zoom lenses are their relatively poor maximum apertures when compared to the larger apertures found on fixed focal length lenses. This will usually require a photographer to use faster films or flash in low light conditions reducing the quality or mood of the final image. The decision to purchase fixed or zoom lenses should be made after much consideration of the many pros and cons. Discuss your preferences with experienced photographers rather than sales staff in camera stores.

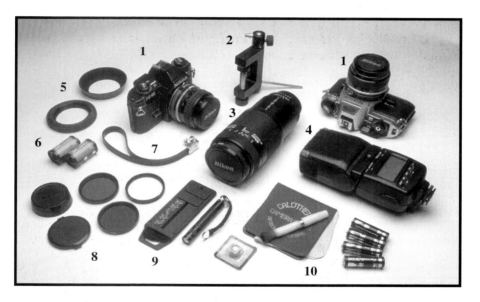

*35mm SLR Equipment*

1. 35mm SLR camera + second camera body (same make as first)
2. Tripod, G-clamp with camera mount or bean bag
3. Additional lenses - fixed or zoom to cover wide angle to telephoto
4. Flash - dedicated or automatic
5. Lens hoods - (designed for widest focal length of the lens)
6. Film - (B & W and colour between 25 - 400 ISO)
7. Camera strap - wrist or neck
8. Filters + spare lens caps and body cap
9. Film retriever and pocket torch - for setting controls at night
10. Spare batteries for camera and flash and camera cleaning cloth and brush

# Exposure

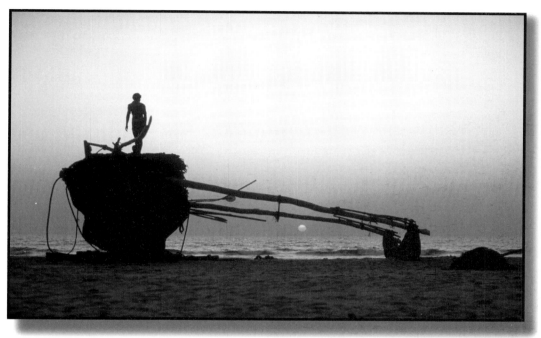

*Mark Galer*

## Aims

~ To develop knowledge and understanding of exposure and its relationship to film, depth of field and selective focus.
~ To develop an understanding of the use of hand held and TTL light meters.
~ To understand the difference between reflected and incident meter readings and their relationship to lighting ratios and exposure.

## Objectives

~ **Research** - Produce research in your Visual Diary that shows an understanding of the affect of exposure in the creation of photographic images.
~ **Discussion** - Exchange ideas and opinions with other students and lecturers on the work you are studying.
~ **Practical work** - Produce colour transparencies through close observation and selection that show an understanding of metering techniques and their relationship to exposure and lighting ratios.

# Introduction

An understanding of exposure is without doubt the most critical part of the photographic process. Automatic exposure systems found in many sophisticated camera systems calculate and set the exposure for the photographer. This may lead some individuals to think that there is only one correct exposure, when in reality there may be several. The exposure indicated by an automatic system, no matter how sophisticated, is an average. Creative photographers use indicated meter readings for guidance only and different photographers may interpret the same reading in different ways to create different images. It is essential that the photographer understands how the illuminated subject is translated by exposure into a photographic image.

## Exposure

Exposure is the action of subjecting a light sensitive film to light. Cameras and lenses expose film by controlling the intensity of light and the length of time (duration) that this light is allowed to strike the film. The intensity of light is determined by the size of the aperture in the lens and the duration of light is determined by the shutter.

**Exposure is controlled by both aperture and shutter – intensity and time.**

Too much light will result in overexposure. Too little light will result in underexposure. It makes no difference whether there is a large or a small amount of light the film still requires the same amount of light for an appropriate exposure.

*Overexposure*                    *Correct exposure*                    *Underexposure*

Film cannot alter its sensitivity to light and adapt to variations in lighting conditions. Exposure has to be adjusted to compensate for these changes. This is achieved by adjusting either the intensity (**aperture**) or duration of light (**time**) entering the camera. An increase in the size of the aperture will give more exposure, a decrease will give less exposure. A decrease in the duration of the shutter speed will reduce exposure, an increase will give more exposure.

# Measuring light

In order to calculate optimum exposure the intensity or level of light has to be measured. The device that measures light is called a light meter. This study guide deals with the metering techniques of both hand-held light meters and those found in most 35mm cameras and some medium format cameras. All light meters give the photographer information about the amount of light available to obtain an appropriate exposure.

The information can be used to set aperture and shutter speed settings in a variety of combinations. Each combination will give different visual outcomes whilst retaining the same overall exposure to the film (see "Creative Controls").

Working in a creative medium such as photography **'correct exposure'** can sometimes be a very subjective opinion. The photographer may want the image to appear dark or light to create a specific mood.

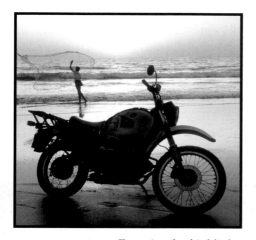

*Exposing for highlights*

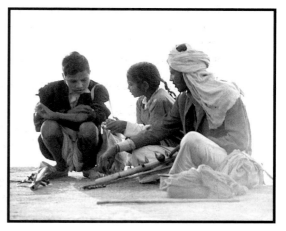

*Exposing for shadows*

# Appropriate exposure

A light meter reading should only be viewed as a guide to exposure. Film is unable to record the broad range of tones visible to the human eye. If the camera frames a subject with bright highlights and dark shadows the film may only be able to capture the highlight tones or the shadow tones, not both. An extremely bright tone and an extremely dark tone cannot both record with detail and texture in the same framed image. Underexposure and overexposure in one image is therefore not only possible but common.

It is often necessary for the photographer to take more than one reading to decide on the most appropriate exposure. If a reading is taken in a highlight area the resulting exposure may underexpose the shadows. If a reading is taken in the shadows the resulting exposure may overexpose the highlights. The photographer must therefore decide whether highlight or shadow detail is the priority, change the lighting or reach a compromise. A clear understanding of exposure and film is essential if the photographer is to make an informed decision.

# Intensity and time

## Intensity

The intensity of light striking the film is controlled by the aperture in the lens. Actual aperture is the size of the diameter of the iris that is built in to the camera lens. The aperture is a mechanical copy of the iris that exists in the human eye. The human iris opens up in dim light and closes down in bright light to control the amount of light reaching the retina. The aperture of the camera lens must also be opened and closed in different brightness levels to control the amount or intensity of light that reaches the film.

The film requires the right amount of light for correct exposure. Too much light and the film will be overexposed, not enough light and the film will be underexposed.

As the aperture on the lens is opened or closed a series of clicks can be felt. These clicks are called f-stops and are numbered. When the number of the f-stop **decreases** by one stop exactly **twice** as much light reaches the film as the previous number. When the number of the f-stop **increases** by one stop **half** as much light reaches the film as the previous number. The only confusing part is that maximum aperture is the f-stop with the smallest number and minimum aperture is the f-stop with the largest number.

The larger the f-stop the smaller the aperture. Easy!

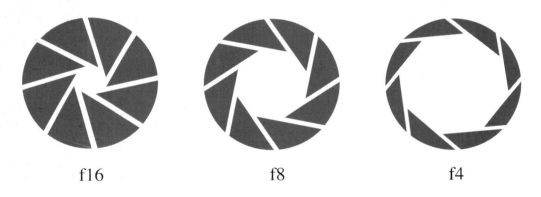

f16                         f8                         f4

## Activity 1

Carefully remove the lens from either a small or medium format camera.

Hold the lens in front of a diffuse light source of low intensity.

Whilst looking through the lens notice how the size of the aperture changes as you alter the f-stop.

Record and discuss the relationship between the size of the aperture and the corresponding f-stop number printed on the barrel of the lens.

# Time

The duration of light striking the film is controlled by the shutter. The time that the film is exposed to light is measured in fractions of a second and this time is dictated by the shutter speed.

Until the invention of the focal plane shutter, exposure time had been controlled by devices either attached to or within the lens itself. These shutters regulated the length of exposure of the film to light. It was not until the invention of a reliable mechanical shutter that exposure times could be relied upon.

As film emulsions became faster (increased sensitivity to light) so did the opportunity to make shorter exposures. Within a relatively brief period exposures were no longer in minutes but in fractions of a second.

*1/4 second (50mm lens)*    *1/15 second (50mm lens)*    *1/60 second (50mm lens)*

# The shutter

There are two main types of shutter systems used in photography, the leaf shutter and the focal plane shutter. The primary function of either system shutter is exposure. When the shutter release is pressed the shutter opens for the amount of time set on the shutter speed dial. These figures are in fractions of seconds. The length of time the shutter is open controls the amount of light that reaches the film, each shutter speed doubling or halving the amount of light.

To slow the shutter speed down is to leave the shutter open for a greater length of time. Shutter speeds slower than 1/60 second using a standard lens can cause motion blur or camera shake unless you brace the camera steady or secure the camera on a tripod.

To use a shutter speed faster than 1/250 or 1/500 second usually requires a wide aperture or a film of increased sensitivity. These measures are necessary to compensate for the small amount of light that can pass through a shutter that is open for such a short amount of time.

**The same exposure or level of illumination can be achieved using different combinations of aperture and shutter speed. For example, an exposure of f11 @ 1/125 second = f8 @ 1/250 second = f16 @ 1/60 second, etc.**

## Leaf shutter

Leaf shutters are situated in the lens assembly of most medium format and all large format cameras. They are constructed from a series of overlapping metal blades or leaves. When the shutter is released the blades swing fully open for the designated period of time.

## Focal plane shutter

A focal plane shutter is situated in the camera body directly in front of the film plane (where the image is focused), hence the name. This system is used extensively in 35mm SLR cameras and a few medium format cameras. The system can be likened to two curtains one opening and one closing the shutter's aperture or window. When the faster shutter speeds are used the second curtain starts to close the before the first has finished opening. A narrow slit is moved over the film plane at the fastest shutter speed. This precludes the use of high speed flash. If flash is used with the fast shutter speeds only part of the frame is exposed.

The advantages of a focal plane shutter over a leaf shutter are:

~    fast shutter speeds in excess of 1/1000 second
~    lenses are comparatively cheaper because they do not require shutter systems.

The disadvantage is:

~    limited flash synchronisation speeds.

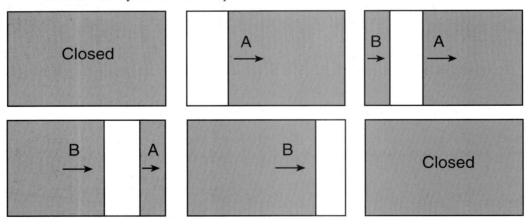

*Focal plane shutter firing faster than the flash sychronisation speed*

# Activity 2

Load a film with colour transparency film. Make two exposures at each shutter speed between 1/125 and 1/4 second whilst hand holding a camera.
Correct the exposure using the aperture each time the shutter speed is adjusted.
Compare and discuss your results with other students to see who has the least image blur.
Take exposure readings of a subject in bright sunlight and covered shade.
Record all of the different combinations of exposure for each lighting condition.

# Hand-held light meters

Accurate exposure of film is critical to the final quality of the photographic image. It is therefore essential to have a reliable light meter. The ability of the human eye to compensate for variations in light, shade and contrast is far greater than any of the film emulsions currently available. It is difficult to appreciate how the difference between dark and light tones and the balance between different light sources (lighting ratio) will translate into a photographic image without the use of a meter.

Next to a camera the light meter is often considered the most important piece of photographic equipment. Most 35mm cameras and some medium format cameras have built-in metering systems that measure light reflected from the subject back to the camera. Although very useful these reflected light meters do not provide information to the photographer about the levels of light falling on the subject. Photographers requiring this information a need a separate hand held meter. Without a meter only experience will tell you if there is going to be detail in the shadows or highlights when the film is exposed.

## Meter readings

Measuring light for exposure can be achieved by taking a reflected or an incident reading. A **reflected reading** is when the light sensitive cell of the meter is pointed at the subject and the light reflected from the subject is measured.

An **incident reading** is when the meter's light sensitive cell is pointed at the camera from the subject and the light falling on the subject is measured. A white plastic diffusing dome commonly referred to an **'invercone'** is placed over the meter's light sensitive cell. The invercone measures the light from a wide field of vision (180°) and transmits 18% of that light to the meter's cell.

## Meter indicated exposure

The indicated exposure reading is known as the **'meter indicated exposure'** or **'MIE'**. Although the photographer sees a subject, the meter sees only a level of light. The meter is calibrated to render everything as an average medium tone or **'mid-tone'**, regardless of the level of illumination. A meter will therefore give correct exposure for a man in a medium grey flannel suit whether he is in a cellar or sunlight.

## 18% grey card

The mid-tone to which all meters are calibrated is called an **'18% grey card',** so called because it reflects 18% of the light falling upon it. It is an exposure and colour standard manufactured by Kodak. If a meter reading is taken from any single tone the resulting MIE will render the tone as a mid-tone. If a meter reading is taken from a black card the resulting MIE will render the black card grey. If a meter reading is taken from a white card the resulting MIE will render the white card grey. This is why snow often comes out grey in many snapshots.

# Taking a hand-held meter reading

## Incident reading

For an incident reading it is important to place the white plastic dome supplied with the meter over the light sensitive cell. This diffuser is commonly referred to as an **'invercone'**. The purpose of the invercone is to scramble or integrate the light falling on the subject from a wide angle of view (180°) and transmit 18% of that light. The sensitivity or ISO of the film must then be dialled into the meter. The light meter is generally taken to the subject and the light sensitive cell is directed back towards the camera. When the reading button is depressed the meter may indicate an EV which must then be interpreted into an aperture/shutter speed combination. On modern digital meters the photographer is able to pre-select a particular shutter speed or aperture and have the meter indicate the corresponding value to obtain the correct exposure.

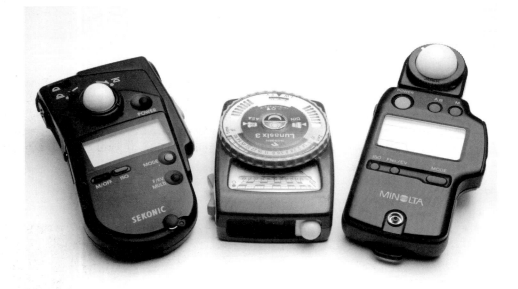

*Hand-held light meters*

## Activity 3

Take an incident light reading of a subject in a constant light source.
Note the f-stop at an exposure time of 1/8 second.
Increase the number of the aperture by three f-stops.
Note the change in exposure time.
Discuss with other students what the result would be if the duration of time had been increased by a factor of three instead of the aperture.

# Reflected reading

For a reflected reading it is important to remove the invercone from the light sensitive cell. The meter's cell has an angle of view equal to a standard lens (with a spot meter attachment the angle of view can be reduced to five degrees for precise measurements). The film's ISO is dialled into the meter. The meter is pointed **towards** the subject.

The exposure that the meter recommends is an average of the reflected light from the light and dark tones present. When light and dark tones are of equal distribution within the field of view this average reading is suitable for exposure. It must be remembered the meter measures only the level of light. It does not distinguish between dark or light tones. If a reading is taken from a single tone the light meter will always indicates an exposure suitable to render this tone as a mid-tone. If the subject is wearing a medium grey flannel suit a reflected reading from the camera would give an average for correct exposure. However if the subject is wearing a white shirt and black jeans a reflected reading of the shirt would give an exposure that would make the shirt appear grey on film. A reflected reading of the jeans would make them appear grey on film. When light or dark tones dominate the photographer must increase or decrease exposure accordingly.

## General reflected reading

If the reading is taken from the camera position a general reading results. This general reading is an average between the reflected light from the range of light and dark tones present. When light and dark tones are of equal distribution within the frame this average light reading is suitable for exposing the subject. When light or dark tones predominate in the image area they overly influence the meters reading and the photographer must increase or decrease exposure accordingly.

## Specific reflected reading

A more accurate reading can be taken when light or dark tones dominate the scene by moving the light meter closer to a mid-tone. This avoids the meter being overly influenced by the former tones. Care must be taken not to cast your own shadow or that of the meter when taking a reading from a close surface.

If the photographer is unable to approach the subject being photographed it is possible to take a meter reading from a substitute tone close to the camera. A popular technique is to use a reading taken from a grey card angled to reflect the same light as the subject or Caucasian skin.

*Specific reflected reading - Tim Roberts*

# TTL light meters

'Through the lens' (TTL) light meters built into cameras measure the level of reflected light prior to exposure. They measure only the reflected light from the subject matter within the framed image. The meter averages out or mixes the differing amounts of reflected light in the framed image and indicates an average level of reflected light. The light meter readings can be translated by the camera's **'central processing unit'** (CPU) and used to set aperture and/or shutter speed.

## Centre-weighted and matrix metering

**'Centre weighted'** and **'matrix metering'**, common in many cameras, bias the information collected from the framed area in a variety of ways. Centre-weighted metering takes a greater percentage of the information from the central area of the viewfinder. The reading, no matter how sophisticated, is still an average - indicating one exposure value only. Any single tone recorded by the photographer using a TTL reading will reproduce as a mid-tone, no matter how dark or light the tone or level of illumination. This tone is the midpoint between black and white. If the photographer takes a photograph of a black or white wall and uses the indicated meter reading to set the exposure, the final image produced would show the wall as having a mid-tone.

*Centre-weighted TTL metering*

## Automatic TTL exposure modes

If the camera is set to fully automatic or programme mode both the shutter speed and aperture will be adjusted automatically so that the correct exposure will usually be obtained. In low light the photographer using the programme mode should keep an eye on the shutter speed which is being used to achieve the correct exposure. The reason for this is that as the lens aperture reaches its widest setting the programme mode will start to use shutter speeds slower than ones usually recommended to avoid camera shake. Many cameras alert the photographer when this happening using an audible signal. This should not be treated as a signal to stop taking photographs but as one to take precautions to avoid camera shake such as bracing the camera in some way.

# Semi-automatic

The disadvantage to a fully automatic or programme mode on a camera is that it can often take away the creative input the photographer can make to many of the shots. A camera set to fully automatic is programmed to make decisions which are not necessarily correct in every situation.

If your camera is selecting both the aperture and shutter speed you may like to consider spending some time finding out how the camera can be switched to semi-automatic and manual operation.

Semi-automatic exposure control, whether aperture priority (Av) or shutter priority (Tv) allow creative input from the photographer (see "Creative Camera Control") but still ensure the MIE exposure is obtained automatically.

# Aperture priority (Av)

This is a semi-automatic function whereby the photographer chooses the aperture and the camera selects the shutter speed to achieve the MIE exposure. This is the most common semi-automatic function used by professional photographers as the **'depth of field'** is usually the primary consideration when creating an image.

When aperture priority is selected the photographer needs to be aware of slow shutter speeds in low light conditions or when using small apertures. To avoid camera shake and unintended blur in these instances the photographer has a number of options:

~ Select a wider aperture.
~ Use a faster film (one with a higher ISO).
~ Mount the camera on a tripod.
~ Use a shorter focal length lens.
~ Brace the camera by supporting or resting your elbows, arms or hands on or against a stable surface.

With practice the skilled photographer is usually able to use shutter speeds slower than the minimum recommended by the manufacturers.

# Shutter priority (Tv)

This is a semi-automatic function whereby the photographer chooses the shutter speed and the camera selects the aperture to achieve the correct exposure. In choosing a fast shutter speed the photographer needs to be aware of underexposure when the light levels start to drop. The fastest shutter speed possible is often limited by the maximum aperture of the lens. In choosing a slow shutter speed the photographer needs to be aware of over-exposure when photographing brightly illuminated subject matter. Movement blur may not be possible when using fast film in bright conditions.

# Interpreting the meter reading

The information given by the light meter after taking a reading is referred to as the **'meter indicated exposure' (MIE).** This is a guide to exposure only.  The light meter should not be perceived as having any intelligence or creative sensibilities.  The light meter cannot distinguish between tones or subjects of interest or disinterest to the photographer.  It is up to the photographer to decide on the most appropriate exposure to achieve the result required.  A photographer with a different idea and outcome may choose to vary the exposure.  It is the photographer's ability to interpret and vary the meter-indicated exposure to suit the mood and communication of the image that separates their creative abilities from others.

If light or dark tones dominate the indicated exposure will be greatly influenced by these dominant tones.  Using the MIE will expose these dominant dark or light tones as mid-tones.  Minority light and mid-tones will be over or underexposed.  If you consider interest and visual impact within a photograph is created by the use of lighting and subject contrast (amongst many other things) the chances of all the elements within in the frame being mid-tones are remote. The information, mood and communication of the final image can be altered through adjusting exposure from MIE.

## Average tones

Consider a subject of average reflectance (mid-tone) placed with equal dark and light tones.  All three tones are lit equally by the same diffuse light source.

A reflected reading of the mid-tone will give correct exposure.  An exposure using the reflected reading of the dark tone will render it grey and overexpose the mid and light tones.  An exposure using the reflected reading of the light tone will render it grey and underexpose the mid and dark tones.

An incident reading will give 'correct' exposure regardless of which tone it is held in front of because it measures the light falling on the subject, not the light reflected from it.   The intensity of the light source is constant but the reflected light from the three tones varies.

## Activity 4

Take a reflected light reading with a hand-held meter positioned 30 centimetres from an 18% grey card.  Note the exposure reading.  Ensure the light source you are using does not vary in intensity.  Now take an incident reading from the grey card with the invercone pointing back towards where you were standing when you took the reflected reading.  Note the exposure readings.

Expose a subject with dominant mid-tones in both bright and dull illumination using the MIE. Keep a record of both exposures and label the results.  Discuss the similarities and differences of each image.

# Dominant dark tones

A subject of average reflectance (mid-tone) is photographed with dominant dark tones. All three tones are lit equally by the same diffuse light source. A reflected light meter reading is taken from the camera. The dominant dark tones reflect less light than 18% grey so the meter indicates an increased exposure compared to a meter reading taken from a mid-tone. The MIE, if used, will result in the dark tones becoming mid-tones and the mid-tones overexposing. If the tones are to be recorded accurately the exposure must be reduced (less time or less light) from that indicated. The amount of reduction is dictated by the level of dominance of the dark tones.

An incident reading will give 'correct' exposure regardless of which tone it is held in front of because it measures the light falling on the subject, not the light reflected from it. The intensity of the light source is constant but the reflected light from the tones varies.

*Dominant light tones - Kate Tan*          *Dominant dark tones - Catherine Yap*

# Dominant light tones

A subject of average reflectance (mid-tone) is photographed with dominant light tones. All the tones are lit equally by the same diffuse light source. A reflected light meter reading is taken from the camera. The dominant light tones reflect more light than 18% grey so the meter indicates a decreased exposure compared to a meter reading taken from a mid-tone. The MIE if used will result in the light tones becoming mid-tones and the mid-tones underexposing. If the tones are to be recorded accurately the exposure must be increased (more time or more light) from that indicated. The amount of increase is dictated by the level of dominance of the light tones.

An incident reading will give 'correct' exposure regardless of which tone it is held in front of because it measures the light falling on the subject, not the light reflected from it. The intensity of the light source is constant but the reflected light from the tones varies.

## Activity 5

Photograph two subjects that require adjusted exposure from that indicated by the light meter. State how the dominant tones would have effected the light meter reading and how the image would have looked if you had not adjusted the exposure.

# Revision exercise

Q1.    True or false?  Maximum aperture = f22, minimum aperture = f2.8.

Q2.    If the exposure meter reading indicates an exposure of 1/60 second @ f8 what would be the correct aperture if the shutter speed was changed to 1/8 second?

Q3.    Changing exposure from f4 @ 1/60 second to f11 @ 1/30 second has increased or decreased the exposure?

Q4.    A reflected reading measures the light reflecting from a subject.  What does an incident reading measure?

Q5.    Will increasing the exposure give more detail in the highlights or shadows?

Q6.    What degree of increased exposure from a reflected light meter reading would you expect to have to use when photographing snow covered ski fields that are receiving full illumination from the midday sun?

Q7.    Name two advantages of a focal plane shutter compared to a leaf shutter.

Q8.    What is a general reflected reading?

Q9.    How does this differ from an incident reading of the same subject?

# Resources

*Advanced Photography - Langford, Michael.*   Focal Press. London.  1997.
*American Cinematographer Manual.*  ASC Press. Hollywood.  1993.
*Basic Photography - Michael Langford.*  Focal Press. London.  1997.
*Black and White Photography - Rand/Litschel.*  West Publishing Co. Minneapolis.  1994.
*Encyclopedia of Photography.*  Crown Publishers. New York.  1984.
*Kodak Professional Products.*  Kodak (Australasia) Pty. Ltd. Melbourne.  1998.
*Light Science and Magic - Hunter and Fuqua.*  Focal Press. Boston.  1997.
*Photographing in the Studio - Gary Kolb.*  Brown & Benchmark. Wisconsin.  1993.
*Photography - London and Upton.*  Harper Collins College Publishers. New York.  1994.
*The Complete Photographer - Gus Wylie.*  Pyramid Books. London.  1989.
*The Focal Encyclopedia of Photography.*  Focal Press. London.  1993.

# Framing the Subject

*Mark Galer*

## Aims

~ To develop an awareness of how a photographic print is a two-dimensional composition of lines, shapes and patterns.
~ To develop an understanding of how differing photographic techniques can affect both the emphasis and the meaning of the subject matter.

## Objectives

~ **Research** - Research the composition of different photographs and the techniques employed by the photographers.
~ **Discussion** - Exchange ideas and opinions with other students.
~ **Practical work** - Produce photographic prints through close observation and selection that demonstrate how the frame can create compositions of shape, line and pattern.

# Introduction

Capturing or creating strong images relies primarily on the photographer's ability to study the subject carefully, enthusiastically, imaginatively and sympathetically. The equipment can only help to craft the photographer's personal vision. Most people are too preoccupied to look at a subject for any great amount of time. Skilled observation by the photographer can release the extraordinary from the ordinary. The famous British photographer Bill Brandt in 1948 is quoted as saying:

**"It is the photographer's job to see more intensely than most people do. He must keep in him something of the child who looks at the world for the first time or of the traveller who enters a strange country."**

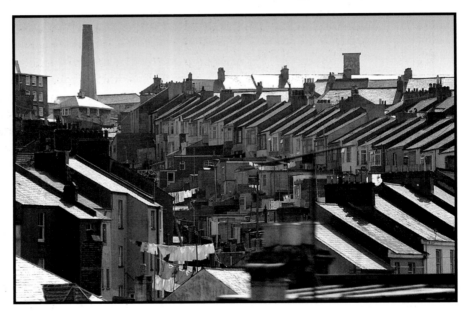

*Terraces*

# Framing techniques

The following techniques should be considered when the photographer wants to control the communication, impact and design of any image.

- ~ **Communication and context**
- ~ **Format**
- ~ **Content**
- ~ **Balance**
- ~ **Subject placement**
- ~ **The decisive moment**
- ~ **Vantage point**
- ~ **Use of line**

# Communication and context

Photographs provide us with factual information. With this information we can make objective statements concerning the image. Objective statements are indisputable facts. Photographic images are an edited version of reality. With limited or conflicting information within the frame we are often unsure of what the photograph is really about. In these cases we may make subjective decisions about what the photograph is communicating to us personally. Subjective statements are what we think or feel about the image. Subjective opinion varies between individuals and may be greatly influenced by the caption that accompanies the image and/or our cultural or experiential background.

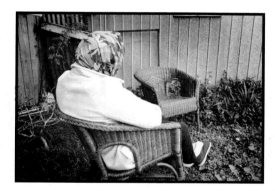

*Old woman - Jonathon Tabensky*

What do we know about this lady or her life other than what we can see in the photograph? Can we assume she is lonely as nobody else appears within the frame? Could the photographer have excluded her grandchildren playing close at hand to improve the composition or alter the meaning? Because we are unable to see the event or the surroundings that the photograph originated from we are seeing the subject out of context.

# Activity 1

Read the following passage taken from the book *The Photographer's Eye* by John Szarkowski and answer the question below.

**"To quote out of context is the essence of the photographer's craft. His central problem is a simple one: what shall he include, what shall he reject? The line of decision between in and out is the picture's edge. While the draughtsman starts with the middle of the sheet, the photographer starts with the frame.**
**The photograph's edge defines content. It isolates unexpected juxtapositions. By surrounding two facts, it creates a relationship. The edge of the photograph dissects familiar forms, and shows their unfamiliar fragment. It creates the shapes that surround objects.**
**The photographer edits the meanings and the patterns of the world through an imaginary frame. This frame is the beginning of his picture's geometry. It is to the photograph as the cushion is to the billiard table."**

**Q.** What does John Szarkowski mean when he says that photographers are quoting 'out of context' when they make photographic pictures? Use two examples to illustrate a 300-word discussion to explain communication and context.

# Format

Format refers to the size and shape of an image. A certain amount of confusion can surround this term. It applies to both **'camera format'** and **'image format'**. An image can be taken or cropped in the vertical or horizontal format using different format cameras. A vertical image (one that is tall and narrow) is described as **'portrait format'** even if the image is a natural landscape. A horizontal image is described as **'landscape format'** even if the subject is a portrait. The origins of this terminology date back to when traditional artists were a little more conservative with their intended use of the frame.

In editorial work photographers must ensure that images are taken using both vertical and horizontal formats. This gives the graphic artists the flexibility to design creative pages.

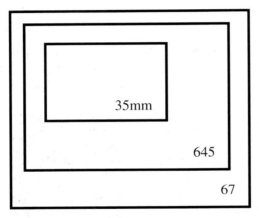

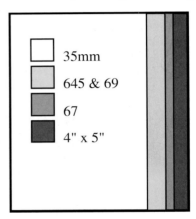

*Relative size of formats*                    *Relative shape of formats*

## Camera format

Format is also used to describe the size of camera being used, i.e. small, medium and large format cameras. Each of these cameras uses a different size of film. The decision to use a particular format may rest with the client's requirements for print quality.

35mm cameras expose frames that are narrow when compared to the average single editorial page. All medium format cameras use 120 roll film but the format of the image can vary. The smallest and largest of the medium format cameras (645 and 69 cameras) expose frames that are in proportion to the size of this page, i.e. if the image was enlarged from the negative it would fill this page without having to crop either side. When enlarging the images from these negatives they correspond to 7" x 9 1/2" printing paper. The 66, 67, 68 and large format cameras expose frames that are shorter than the average editorial page. Care needs to be taken when using these cameras for editorial work. The photographer has to be prepared to lose some of the visible image in the viewfinder if an editor wants to produce a full-page image. Many photographers instinctively design full frame. This can later create difficulties when trying to crop the image to a different format. This problem may be overcome by masking off the viewing area to the image shape required by the client.

# Content

An essential skill of framing is to view the subject in relation to its background. This relationship between subject and background is often referred to as **'figure and ground'**. Many photographers stand too far away from the subject. In a desire to include all the subject their photographs become busy, unstructured and cluttered with unwanted background detail. This extra detail can distract from the primary subject matter.

If a photographer moves closer, or chooses an alternative vantage point from which to take the image, distracting background can be reduced or eliminated. With fewer visual elements to be arranged the photographer has more control over composition. If background detail does not relate to the subject the photographer should consider removing it from the frame. Unless the photograph is to act as a factual record the need to include everything is unnecessary. William Albert Allard, a photographer for National Geographic, says:

**"What's really important is to simplify. The work of most photographers would be improved immensely if they could do one thing: get rid of the extraneous. If you strive for simplicity, you are more likely to reach the viewer."**

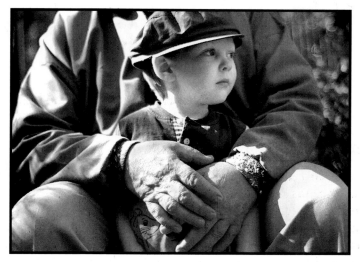

*Matthew*

In the image above the protective hands provide all the information we need to understand the relationship between these people. In order to clarify this, the photographer could have moved further back. With increased background information the power of this portrait would have been lost. Photographers have the option however of taking more than one photograph to tell a story.

# Activity 2

Find two examples of how photographers seek simple backgrounds to remove unwanted detail and to help keep the emphasis or **'focal point'** on the subject.

# Balance

In addition to content a variety of visual elements such as line, colour and tone often influence a photographer's framing of an image. The eye naturally or intuitively seeks to create a symmetry or a harmonious relationship between these elements within the frame. When this is achieved the image is said to have a sense of balance. The most dominant element of balance is visual weight created by the distribution of light and dark tones within the frame. To frame a large dark tone on one side of the image and not seek to place tones of equal visual weight on the other side will create imbalance in the image. An image that is not balanced may appear heavy on one side. Visual tension is created within an image that is not balanced. Balance, although calming to the eye, is not always necessary to create an effective image. Communication of harmony or tension is the deciding factor of whether balance is desirable in the image.

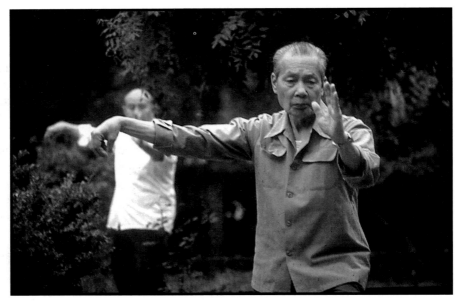

*Tai Chi*

# Activity 3

Collect one image where the photographer has placed the main subject off-centre and retained a sense of balance and one image where the photographer has placed the main subject off-centre and created a sense of imbalance.
Discuss the possible intentions of the photographer in creating each image.
Create four images placing the focal point and/or visual weight in different areas of the frame.
Discuss whether each image is balanced or unbalanced.

# Subject placement

Balance may be easily achieved by placing the subject in the middle of the frame. The resulting image does not encourage the viewers eye to move around the image. This leads to a static composition, making little demand on the viewer.

**The photographer should think carefully where the main subject is placed within the image, only choosing the central location after much consideration.**

When the subject is framed the photographer should examine the image as if it was a flat surface. This action will help the photographer become aware of unnecessary distractions to the basic design. A common mistake made by photographers is to become preoccupied with the subject, forgetting to notice background detail. This can lead to the problem of previously unnoticed trees or lampposts apparently growing out of the top of people's heads when the final image is viewed.

## The rule of thirds

Rules of composition have been formulated to aid artists create harmonious images. The most common of these rules are the 'golden section' and the 'rule of thirds'. The Golden Section is the name given to a traditional system of dividing the frame into unequal parts which dates back to the time of Ancient Greece.

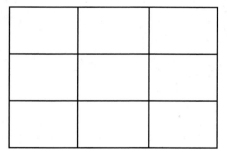

The rule of thirds is the simplified modern equivalent. Visualise the viewfinder as having a grid which divides the frame into three equal segments, both vertically and horizontally. Photographers often use these lines and their intersection points as key positions to place significant elements within the picture.

*The rule of thirds*

## Breaking the rules

Designers who are aware of these rules often break them by deliberately placing the elements of the image closer to the edges of the frame. This can often be effective in creating dynamic tension where a more formal design is not needed.

# Activity 4

Find two examples of photographs that follow the rule of thirds and two that do not. Comment briefly on why and how you think the composition works.
Create two images that conform to the rule of thirds.

# The decisive moment

The famous photographer Henri Cartier-Bresson in 1954 described the visual climax to a scene which the photographer captures as being the 'decisive moment'.

The moment when the photographer chooses to release the shutter may be influenced by the visual climax to the action and the moment when the moving forms create the most pleasing design. In the flux of movement a photographer can sometimes intuitively feel when the changing forms and patterns achieve balance, clarity and order and when the image becomes for an instant a picture.

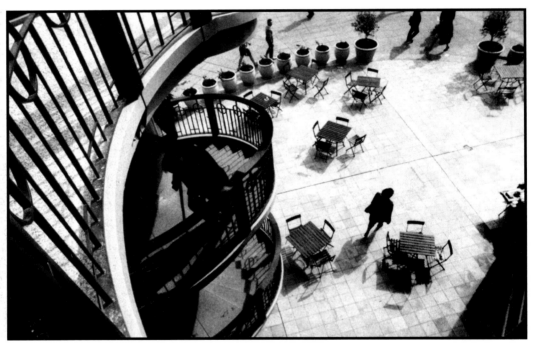

*Michael Wennrich*

To capture decisive moments the photographer needs to be focused on, or receptive to, what is happening rather than the camera equipment they are holding. Just like driving a car it is possible to operate a camera without looking at the controls. The photographer must spend time with any piece of equipment so that they are able to operate it intuitively. When watching an event unfold the photographer can increase their chances of capturing the decisive moment by presetting the focus and exposure.

## Activity 5

Create four images that capture the decisive moment of an action or interaction.
Discuss the balance or imbalance of each image.

# Vantage point

A carefully chosen viewpoint or 'vantage point' can often reveal the subject as familiar and yet strange. In designing an effective photograph that will encourage the viewer to look more closely, and for longer, it is important to study your subject matter from all angles. The 'usual' or ordinary is often disregarded as having been 'seen before' so it is sometimes important to look for a fresh angle on a subject that will tell the viewer something new. The use of a high or low vantage point can overcome a distracting background by removing unwanted subject matter, using the ground or the sky as an empty backdrop.

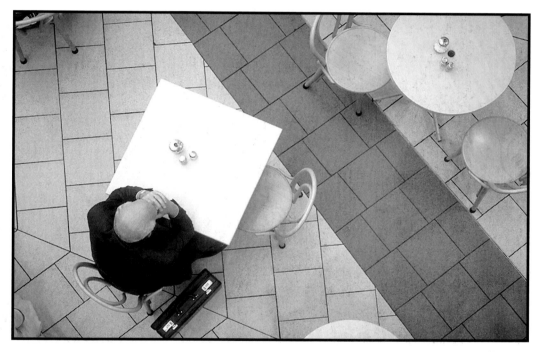

*Waiting*

# Activity 6

Find two examples of photographs where the photographer has used a different vantage point to improve the composition.

Comment on how this was achieved and how this has possibly improved the composition or interest of the image.

Capture four images using a variety of unusual or interesting vantage points. Seek to simplify the content by the choice of vantage point in at least two of the images.

# Line

The use of line is a major design tool that the photographer can use to structure the image. Line becomes apparent when the contrast between light and dark, colour, texture or shape serves to define an edge. The eye will instinctively follow a line. Line in a photograph can be described by its length and angle in relation to the frame (itself constructed from lines).

## Horizontal and vertical lines

Horizontal lines are easily read as we scan images from left to right comfortably. The horizon line is often the most dominant line within the photographic image. Horizontal lines within the image give the viewer a feeling of calm, stability and weight. The photographer must usually be careful to align a strong horizontal line with the edge of the frame. A sloping horizon line is usually immediately detectable by the viewer and the feeling of stability is lost.

Vertical lines can express strength and power. This attribute is again dependent on careful alignment with the edge of the frame. This strength is lost when the camera is tilted to accommodate information above or below eye level. The action of perspective causes parallel vertical lines to lean inwards as they recede into the distance.

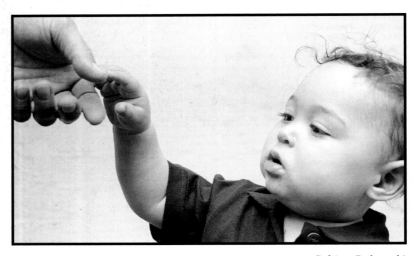

*Sabina Bukowski*

## Suggested and broken line

Line can be designed to flow through an image. Once the eye is moving it will pick up a direction of travel and move between points of interest. The photograph above is a good example of how the eye can move through an image. Viewers tend to look briefly at the adult hand holding the child's, before quickly moving down the arm to the face. The direction of the child's gaze returns the viewers attention to the hands. A simple background without distracting detail helps to keep our attention firmly fixed on this relationship.

## Diagonal lines

Whether real or suggested, these lines are more dynamic than horizontal or vertical lines. Whereas horizontal and vertical lines are stable, diagonal lines are seen as unstable (as if they are falling over) thus setting up a dynamic tension or sense of movement within the picture.

*Daimaru*

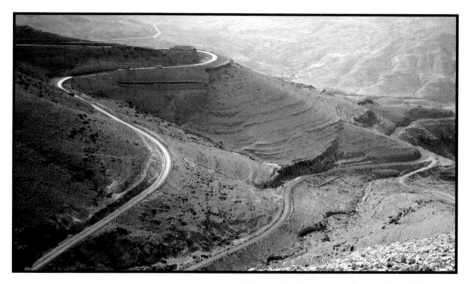

*Kings Highway, Jordan - Max Wiseberg*

## Curves

Curved line is very useful in drawing the viewer's eye through the image in an orderly way. The viewer often starts viewing the image at the top left hand corner and many curves exploit this. Curves can be visually dynamic when the arc of the curve comes close to the edge of the frame or directs the eye out of the image.

## Activity 7

Find two examples of photographs that use straight lines as an important feature in constructing the pictures' composition.

Find one example where the dominant line is either an arc or S-curve.

Comment briefly on the contribution of line to the composition of each example.

Construct an image where the viewer is encouraged to navigate the image by the use of suggested line and broken line between different points of interest.

# Depth

When we view a flat two-dimensional print which is a representation of a three- dimensional scene, we can often recreate this sense of depth in our mind's eye. Using any perspective present in the image and the scale of known objects we view the image as if it exists in layers at differing distances. Successful compositions often make use of this sense of depth by strategically placing points of interest in the foreground, the middle distance and the distance. Our eye can be led through such a composition as if we were walking through the photograph observing the points of interest on the way.

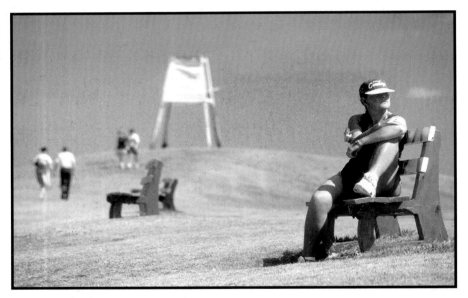

*Jogger*

In the image above our eyes are first drawn to the figure occupying the foreground by use of focus. Our attention moves along a sweeping arc through the bench to the people on the far left side of the frame and finally to the distant figures and tower.

A greater sense of depth can be achieved by making optimum use of depth of field, careful framing, use of line, tone and colour. In this way the viewer's attention can be guided through an image rather than just being drawn immediately to the middle of the frame, the point of focus and the principal subject matter.

## Activity 8

Find two photographs where the photographer has placed subject matter in the foreground, the middle distance and the distance in an attempt either to fill the frame or draw our gaze into the image.

Comment briefly on where you feel the focal points of these images are.

# Summary of basic design techniques

- Simplify content.

- Vary the use of horizontal and vertical formats.

- Limit static compositions by placing the main subject off centre.

- Create balance or tension by arrangement of tone within the frame.

- Explore alternative vantage points from which to view the subject.

- Arrange lines within the frame to reinforce or express feeling and to guide the viewer through the image.

- Choose the desired perspective by the considered use of focal length and viewpoint.

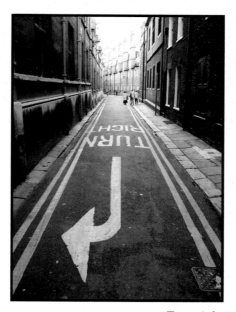

*Turn right*

# Resources

*Basic Photography - Michael Langford.*  Focal Press.  London.  1997.
*Black and White Photography - Rand/Litschel.*  West Publishing Co. Minneapolis.  1994.
*Photography Composition - Tom Grill and Mark Scanlon.*  Fountain Press Ltd.  1984
*Photography - London and Upton.*  Harper Collins College Publishers.  New York.  1994.
*The Image - Michael Freeman.*  Collins Photography Workshop.
*The Photographer's Eye - John Szarkowski.*  Museum of Modern Art.  New York.  1966.

# Gallery

*Sabina Bukowski*

*Mark Galer*

*Michael Mullan*

# Creative Camera Control

*Mark Galer*

## Aims

~ To increase knowledge and understanding about aperture, shutter speed and focal length and their combined effects on visual communication.
~ To increase student familiarity and fluency with personal camera equipment.

## Objectives

~ **Research** - Research professional photographic practice to demonstrate a visual understanding of applied camera technique.
~ **Discussion** - Exchange information with other students
~ **Practical work** - Produce images that demonstrate a working knowledge of depth of field, timed exposures and perspective.
Control communication and visual effect through considered use of focus, blur and perspective.

# Introduction

In the section on framing the image we have looked at how the camera is a subjective recording medium that can communicate and express the ideas of individual photographers. We have seen how the choice of subject and the arrangement or design of this subject within the frame has enormous potential to control communication. This communication can be further enhanced by varying the way we use the equipment and its controls in order to create or capture images. The student is advised to consider the application of technical effects very carefully so that the resulting images are primarily about the communication of content and not technique. Technique should never be obtrusive.

The principal techniques that enable photographers on location to communicate in controlled ways are:

~ **Focus**
~ **Duration of exposure**
~ **Perspective**

## Familiarity with equipment

Large amounts of equipment does not make students better photographers. It is essential that students first become familiar with what they own before acquiring additional equipment. The camera must become an extension of the photographer so it can be operated with the minimum of fuss. The equipment must not interfere with the primary function of seeing.

**The camera is a tool to communicate the vision of the photographer.**
**Creative photography is essentially about seeing.**

# Focus

The word **'focus'** refers to either the point or plane at which an image is sharp or the 'centre of interest'. When an image is being framed the lens is focused on the subject which is of primary interest to the photographer. The viewer of an image is instinctively drawn to this point of focus or the area of the image which is the most sharp. This becomes the **'focal point'** of the image. In this way the photographer guides or influences the viewer to not only look at the same point of focus but also share the same point of interest.

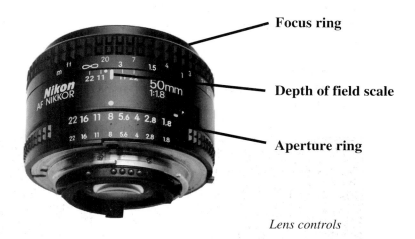

Focus ring

Depth of field scale

Aperture ring

*Lens controls*

## Limitations of focus

When an object is made sharp by focusing the lens all other subjects at the same distance are equally sharp. Subjects nearer or further away are progressively less sharp.
The focusing ring on the lens can be rotated between two stops at which point it can no longer be turned to alter focus. As the subject moves closer to the lens a distance is reached where the subject can no longer be focused . The focusing ring will not turn further and reaches its stop. This represents the **'closest point of focus'**. As the subject moves further away the focusing ring again reaches a point where it will not turn further. This distance is called **'infinity'** on the lens and is represented by the symbol ∞ . At increasing distances from the camera the subject will continue to remain in focus. The closest point of focus and the point of infinity changes between different lenses.

## Activity 1

Record the closest focusing distance of all your lenses. If you have a zoom lens check the closest focusing distance at the shortest and longest focal length.
Take four creatively designed images using the closest focusing distance of your lens.

# Depth of field

In addition to choosing the focal point of the image the photographer can also control how much of the image is perceived as being in focus or sharp.  As the aperture of the lens is progressively reduced in size, subjects in front and behind the point of focus begin to appear sharp.  By choosing the aperture carefully the photographer can single out one person in a crowd or the entire crowd to be in focus.  In this way communication can be dramatically altered.  The zone of acceptable sharp focus is described as the **'depth of field'.**

> **Depth of field can be described as the nearest to the furthest distances where the subject appears acceptably sharp.**

Shallow depth of field is created using the wider aperture settings of the lens.  The difference between the nearest and furthest distance at which the subject is seen as acceptably sharp is small.

Maximum depth of field is created using the smaller aperture settings of the lens.  The difference between the nearest and furthest distance at which the subject is seen as acceptably sharp is great.

> **The widest apertures (f2, f4) give the least depth of field.**
> **The smallest apertures (f16, f22) give the greatest depth of field.**

*Aperture stopped down to f22*                    *Aperture wide open.*

# Depth of field preview

The changes to depth of field affected by aperture are not readily seen in most cameras.  The subject is often viewed through the widest aperture that is held permanently open until the actual exposure is made.  This is to give the photographer a bright image in the viewfinder.  If the photographer wishes to check the depth of field at any given aperture they must use a **'depth of field preview'** or the depth of field scale if available.

# Contributory factors affecting depth of field

Depth of field is also affected by the distance the photographer is positioned from the subject and by the focal length of the lens being used.

**Distance** - As the photographer moves closer to the subject the depth of field becomes narrower. As the photographer moves further away the depth of field becomes greater.

**Focal length** - As the focal length of the lens increases (telephoto lenses) the depth of field becomes narrower. As the focal length of the lens decreases (wide angle lenses) the depth of field becomes greater.

> **The narrowest depth of field is achieved with the widest aperture on a telephoto lens whilst working at the lenses minimum focusing distance.**

**Point of focus** - Except when the photographer is working at very close range to the subject depth of field extends unequally in front and behind the point of focus. Focus increases approximately in the proportion of one third before and two thirds beyond the point of focus.

*Beijing*

# Practical application

All factors affecting depth of field are working simultaneously. Aperture remains the photographers main control over depth of field as framing (usually a primary consideration) dictates the lens and working distance. For maximum control over depth of field the photographer is advised to select aperture priority or manual mode on the camera.

Firstly decide on the subject which is to be the focal point of the image. Second decide whether to draw attention to this subject, isolate the subject entirely or integrate the subject with its surroundings.

Precisely focusing the lens is unnecessary when photographing in bright conditions with small apertures (f11, f16 and f22). Depth of field on a 28mm wide angle lens stopped down to f16 extends from less than one metre to infinity.

# Selective and overall focus

By selecting the quantity of information within the image to be sharp the photographer is said to be using **'selective focus'**. This is a powerful tool to control communication. The photographer is telling the viewer what is important and what is less important.

When the aperture is reduced sufficiently, and the other contributory factors to great depth of field are favourable, it is possible to produce an image where the content of the entire frame is sharp. This effect is described as **'overall focus'**. Overall focus is often difficult to achieve. Unless the level of illumination is bright, or a tripod is available, the photographer runs the risk of **'camera shake'**. Small apertures, such as f16 or f22, often require the use of a very slow shutter speed .

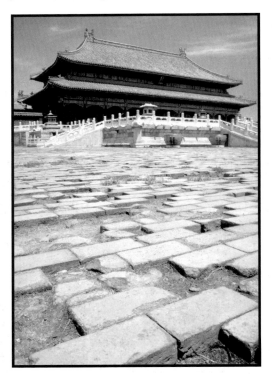

*The forbidden city*

# Maximising depth of field

The photographer can maximise the depth of field and ensure overall focus by focusing approximately one third of the way into the subject. The infinity symbol should be placed on the appropriate mark using the depth of field scale on the lens.

# Activity 2

Take two images using selective focus and two images demonstrating overall focus. Discuss the visual communication of each image.

# Duration of exposure

All photographs are time exposures of shorter or longer duration, and each describes an individually distinct parcel of time.  The photographer, by choosing the length of exposure, is capable of exploring moving subjects in a variety of ways.

By choosing long exposures moving objects will record as blurs.  This effect is used to convey the impression or feeling of motion.  Although describing the feeling of the subject in motion much of the information about the subject is sacrificed to effect.  By selecting fast shutter speeds photographers can freeze movement.  We can see the nature of an object in motion, at a particular moment in time, that the human eye is unable to isolate.

## Fast shutter speeds

By freezing thin slices of time, it is possible to explore the beauty of form in motion.  A fast shutter speed may freeze a moving subject yet leave others still blurred.  This is dependent on the speed of the subject matter and the angle of movement in relation to the camera.  For subject matter travelling across the camera's field of view, relatively fast shutter speeds are required, compared to the shutter speeds required to freeze the same subject travelling towards or away from the camera.

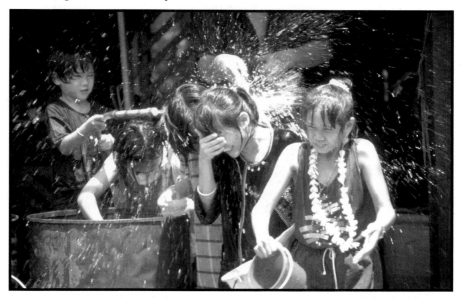

*Songkran festival*

## Limitations of equipment

Wide apertures in combination with bright ambient light and/or fast film allows the use of fast shutter speeds in order to freeze rapidly moving subject matter.  Some telephoto and zoom lenses only open up to f4 or f5.6.  If used with a slow or medium-speed film there is usually insufficient light to use the fastest shutter speeds available on the camera.

# Panning

Photographers can follow the moving subject with the camera in order to keep the subject within the frame. This technique called **'panning'** allows the photographer to use a slower shutter speed than would otherwise have been required if the camera had been static. The ambient light is often insufficient to use the very fast shutter speeds making panning essential in many instances.

For successful panning the photographer must aim to track the subject before the shutter is released and follow through or continue to pan once the exposure has been made. The action should be one fluid movement without pausing to release the shutter. A successful pan may not provide adequate sharpness if the focus is not precise.

In order to have precise focusing with a moving subject the photographer may need to use a fast predictive autofocus system or pre-focus on a location which the moving subject will pass through.

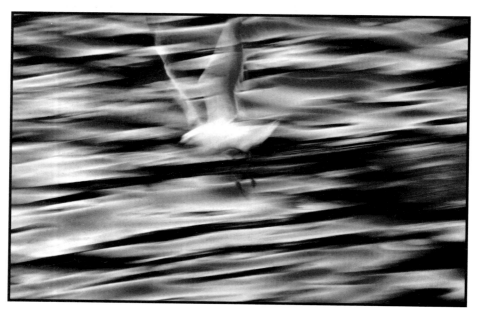

*Bird in flight - Jana Liebenstein*

# Activity 3

Take four images of a running or jumping figure using fast shutter speeds (faster than 1/250 second). Vary the direction of travel in relation to the camera and attempt to fill the frame with the figure. Examine the image for any movement blur and discuss the focusing technique used.

Take four images of the same moving subject using shutter speeds between 1/15 and 1/125 second. Pan the camera to follow the movement. The primary subject should again fill the frame. Discuss the visual effect of each image.

# Slow shutter speeds

When the shutter speed is slowed down movement is no longer frozen but records as a streak across the film.  This is called **'movement blur'**.  By using shutter speeds slower than those normally recommended for use with the lens, movement-blur can be created with relatively slow moving subject matter.  Speeds of 1/30, 1/15, 1/8 and 1/4 second can be used to create blur with a standard lens.  If these slow shutter speeds are used and the camera is on a tripod the background will be sharp and the moving subject blurred.  If the camera is panned successfully with the moving subject the background will provide most of the blur in the form of a streaking effect in the direction of the pan.

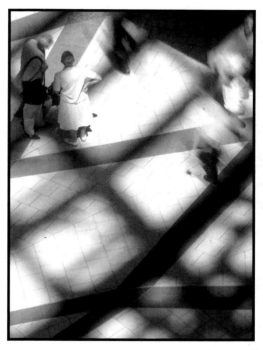

*Daimaru*

# Camera shake

Movement blur may also be picked up from camera movement as a result of small vibrations transmitted to the camera from the photographer's hands.  This is called **'camera shake'**.  To avoid camera shake a shutter speed roughly equal to the focal length of the lens is usually recommended, e.g. 1/30 second at 28mm, 1/60 second at 50mm and 1/125 at 135mm.  Many cameras give an audible signal when shutter speeds likely to give camera shake are being used.

With careful bracing, slower speeds than those recommended can be used with great success.  When using slow shutter speeds the photographer can rest elbows on a nearby solid surface, breathe gently and release the shutter with a gentle squeeze rather than a stabbing action.

# Extended shutter speeds

If the shutter speeds are further reduced information about the subject is eventually lost and the effect of movement may disappear. The technique of very long exposures is often explored in landscape photography where the photographer wants to record the passage of weather or water.

For very long exposures the camera can be mounted on a tripod and the shutter fired using a cable release. Small apertures in combination with slow film such as 50 ISO and light reducing filters such as a neutral density filter or polarising filter will extend the shutter speed to seconds or even minutes.

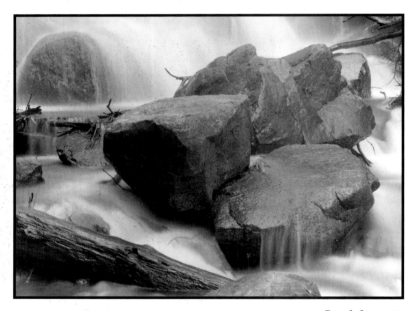

*Sarah Irawatty*

# Reciprocity failure

When using exposures of longer than one second normal daylight film fails to respond accurately to the exposures indicated by the light meter. This is called **'reciprocity failure'** and if the photographer fails to allow for this factor underexposure will occur. For exposures between 1 and 10 seconds the photographer needs to open up approximately half a stop when using colour negative and one stop when using colour transparency or black and white film. For exposures longer than 10 seconds the photographer should increase this compensation to one and one-and-a-half stops respectively.

# Activity 4

Take four images using shutter speeds longer than 1 second. The camera should be braced or secured on a tripod so that stationary subject matter is sharp. Discuss the visual effects of the images.

# A creative decision

The choice between depth of field and shutter speed is often a compromise. Choosing one effect impacts upon the other. The need for correct exposure requires the photographer to make one effect a priority over the other. When the photographer requires overall focus movement blur is likely to occur from the use of a slow shutter speed. When the aperture is opened to achieve shallow depth of field the shutter speed is relatively fast. Movement blur is unlikely unless the photographer is photographing in subdued lighting conditions. Similarly when the photographer requires a reasonably fast shutter speed to avoid camera shake or freeze motion, shallow depth of field is often the result.

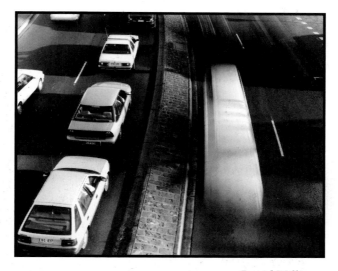

*David Williams*

## Limitations of semi-automatic

When selecting shutter priority mode on a built-in metering system the photographer must take care not to underexpose images. Excessively fast shutter speeds for the available light may require an aperture greater than that available on the lens.

When selecting aperture priority mode on a built-in metering system the photographer must take care not to overexpose images. Excessively wide apertures to create shallow depth of field in bright light may require shutter speeds faster than that available on the lens.

# Activity 5

Record the widest aperture available on each of your lenses when photographing in bright sunlight using 100 and 400 ISO film.

Record the fastest shutter speeds available with each of your lenses when photographing in a variety of interior locations using the existing light only.

Create four images that contain a mixture of solid (sharp) and fluid (blur) form.

# Perspective

Visual **'perspective'** is the way we gain a sense of depth and distance in a two-dimensional print. Objects are seen to diminish in size as they move further away from the viewer. This is called **'diminishing perspective'**. Parallel lines converge as they recede towards the horizon. This is called **'converging perspective'**.

The human eye has a fixed focal length and a fixed field of vision. Apparent perspective in the viewfinder can be altered by changing the focal length of the lens together with the distance of the camera from the subject.

## Steep perspective

Due to a close viewpoint a wide angle lens exaggerates distances and scale, creating 'steep perspective'. Subjects close to the lens look large in proportion to the surroundings. Distant subjects look much further away.

Taken with a wide angle lens, the woman in the foreground looks prominent and the city in the background looks distant. Viewers are drawn into the image via the steep perspective. The use of a wide angle lens in bright sunlight enables great depth of field whilst hand holding a camera.

## Perspective compression

Due to a distant viewpoint a telephoto lens compresses, condenses and flattens three-dimensional space. Subject matter appears closer together. The viewer of an image taken with a telephoto lens often feels disconnected with the subject matter.

*Port Philip Bay*

Taken with a telephoto lens, the perspective compression gives more emphasis to the distant city. It is easy to isolate the subject from the background using wide apertures on telephoto lenses. In overcast conditions or when photographing in the shade slow shutter speeds may cause camera shake.

# Activity 6

Find two photographs where the photographer has used a non-standard focal length lens and viewpoint to alter the perspective.

Comment briefly on the relationship between foreground and background and the perceived sense of depth in the images.

# Summary of basic camera techniques

- Select the focal point of the image and choose selective or overall focus.

- Select the depth of field required using the aperture control.

- Consider the combined effects of:
  - ~ aperture
  - ~ focal length
  - ~ distance from the subject

- To maximise depth of field focus one third of the way into the subject.

- Use a depth of field preview or the depth of field scale to calculate focus.

- Consider the most appropriate choice of shutter speed to freeze or blur the subject.

- Brace the camera when using slower shutter speeds to avoid camera shake.

- Do not exceed the flash synchronisation speed of a focal plane shutter if flash is in use.

- Pan the camera to maximise sharpness of a moving subject.

- Use predictive focus when panning a moving subject.

- Allow for reciprocity failure with exposure times longer than one second.

- Choose the desired perspective by considered use of focal length and viewpoint.

## Resources

*Basic Photography - Michael Langford.* Focal Press. London. 1997
*Black and White Photography - Rand/Litschel.* West Publishing Co. Minneapolis. 1994.
*Photography - London and Upton.* Harper Collins College Publishers. New York. 1994.

# Gallery

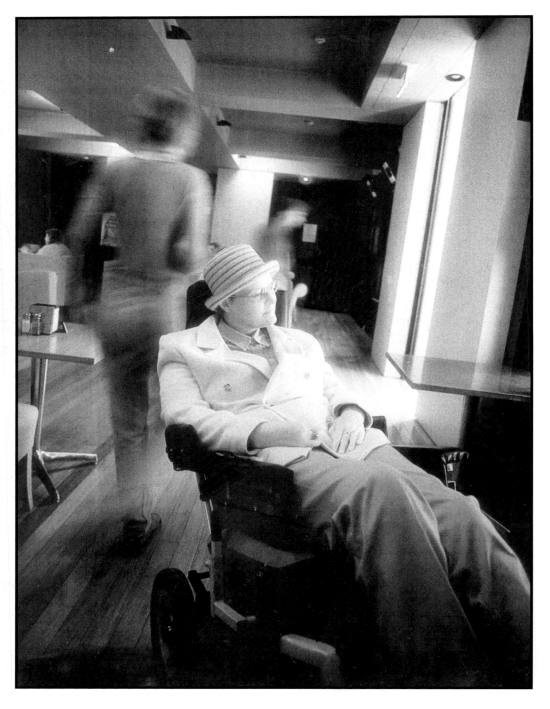

*Michael Mullan*

# Light

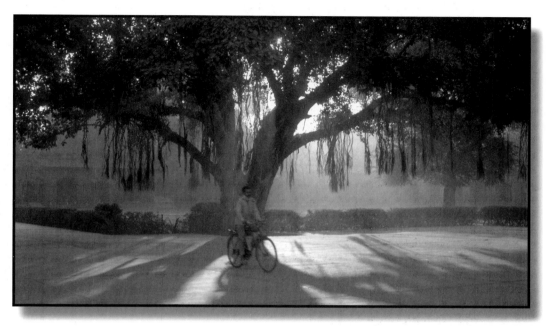

*Mark Galer*

## Aims

~ To develop knowledge and understanding of how light can change the character and mood of subject matter.
~ To develop an awareness of overall subject contrast and how this translates to photographic film.
~ To develop skills in controlling introduced lighting on location.

## Objectives

~ **Research** - Produce research in your visual diary that looks at a broad range of lighting techniques.
~ **Discussion** - Exchange ideas and opinions with other students on the work you are studying.
~ **Practical work** - Produce photographic positives through close observation and selection that demonstrate how lighting techniques control communication.

# Introduction

Light is the photographer's medium.  The word photography is derived from the ancient Greek words, 'photos' and 'graph', meaning light writing.  To be fluent with the language of light the photographer must be fully conversant with its qualities and behaviour.  In mastering the medium the photographer learns to take control over the final image.  To manage the medium takes knowledge, skill and craftsmanship.  It can at first seem a complex and sometimes confusing subject.  With increased awareness and practical experience however, the student finds that light becomes an invaluable tool, rather than an obstacle, to communication.

## Seeing light

In order to manage a light source, we must first be aware of its presence.  Often our preoccupation with content and framing can make us oblivious to the light striking the subject and background.  We simply forget to see the light.

When light falls on a subject it creates a range of tones we can group into three main categories: **Highlights, Mid-tones** and **Shadows.**

Each of the categories can be described by their level of illumination (how dark or bright) and their distribution within the frame.  These are in turn dictated by the relative position of: **Subject, Light source** and **Camera.**

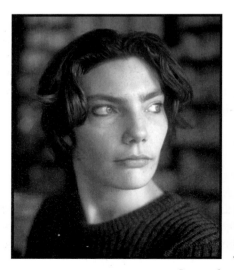   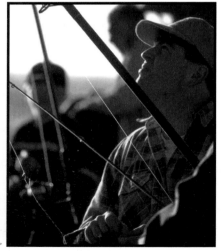

*Image 1*                    *Image 2*

## Activity 1

Describe the above images in terms of highlights, mid-tones and shadows.

Draw a diagram for each to indicate the relative position of subject, light source and camera.

# Ambient light

Ambient light is the existing natural or artificial light that is present in any environment. The photographer may wish to introduce additional lighting but must be able to use the ambient light present, even if the level of this light appears to be very low.

Ambient light can be subdivided into four major categories:

~ Daylight
~ Tungsten
~ Fluorescent
~ Firelight

## Daylight

Daylight is a mixture of sunlight and skylight. Sunlight is the dominant or main light. It is warm in colour and creates the highlights and shadows. Skylight is the secondary light. It is cool in colour and fills the entire scene with a soft diffused light. Without the action of skylight, shadows would be black and detail would not be visible.

Most colour films are calibrated to summer daylight at noon. When images are recorded at this time of the day the colours and tones reproduce with neutral values, i.e. neither warm, nor cool.

## Tungsten

A common type of electric light such as household bulbs /globes and photographic lamps. A tungsten element heats up and emits light. Tungsten light produces very warm colours when used as the primary light source with daylight colour film. Underexposure occurs due to the lack of short blue waves in the spectrum of light emitted. The orange colour cast can be corrected with a blue filter if neutral tones are desired.

## Fluorescent

Phosphors inside fluorescent tubes radiate light after first absorbing ultraviolet light from a mercury vapour discharge. The resulting light produces a strong green cast that is not apparent to human vision. If used as a primary light source the results are often unacceptable due to the broad flat light and the strong colour cast. Underexposure is again experienced when using this light source and the cast can be difficult to correct. Fluorescent light flickers and causes uneven exposure with focal plane shutters. To avoid uneven exposure shutter speeds slower than 1/30 second should be used.

## Firelight

Light from naked flames can be very low in intensity. With very long exposures it can be used to create atmosphere and mood with its rich red tones.

# Characteristics of light

To understand light in depth it is essential to examine its individual characteristics.

- ~ **Intensity and distance of the light**
- ~ **Quality of light**
- ~ **Colour of light**
- ~ **Direction of light**
- ~ **Contrast**

## Intensity

The intensity of light describes how bright the level of ambient light is. The intensity of light falling on the subject can be measured using a light meter. This measurement can be taken using a hand-held light meter. This is called an **'incident reading'**. The 35mm SLR's light meter does not directly measure the intensity of light falling on the subject from the light source, but the level of reflected light. Although the intensity of the light source may remain constant (such as on a sunny day) the level of reflected light may vary. A subject wearing light clothes for instance will reflect more light than a subject wearing dark clothes, even though they may both be standing in the same light. The amount of light reflecting off a surface is called subject reflectance. The level of reflected light is determined by:

- ~ Reflectance of the subject
- ~ Intensity of the light source
- ~ Distance of the subject from the light source
- ~ Angle of the light source

## Fall-off

As the distance between the subject and the light source increases the level of light illuminating the subject decreases. Doubling the distance between the subject and the light source results in only one quarter of the original level of illumination. This rapid lowering in the level of illumination is called fall-off and is governed by the 'Inverse square law'.

Although fall-off does not present a problem when working with direct sunlight, it does need to be considered with reflected light, window light and artificial light sources. The visual effect of subjects at differing distances to the light source is uneven illumination.

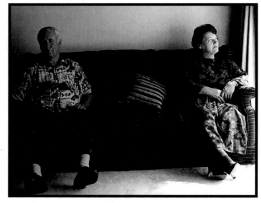

*Light fall-off - David Williams*

*The subject nearest the window received four times the level of illumination even though they are seated only twice as close.*

# Quality

Light  from a point light source such as a light bulb or the sun is described as having a very 'hard quality'.  The shadows created by this type of light are dark and have well-defined edges.  The shadows created by the sun are dark but not totally devoid of illumination.  This illumination is provided by skylight.  The earth's atmosphere scatters some of the shorter/blue wavelengths of light and provides an umbrella of low level light.  Electric light sources create much harsher light when used on their own at night or away from the softening effects of skylight.

The light from a point source can be diffused, spread or reflected off larger surface areas.  Directional light is scattered in different directions when reflecting off a non-shiny surface.  The level of light is lowered but so to is the harshness.  Shadows that were receiving very little light when compared to the highlights now receive proportionally more.  The light is now said to have a softer quality.  The shadows are less dark (detail can be seen in them) and the edges are no longer clearly defined.

*Harsh light*                                    *Soft light*

**The smaller the light source, the harder the light appears.**
**The larger the light source, the softer the light appears.**

The control over quality of light is an essential skill when on location.  Often the photographer will encounter scenes where the quality of the ambient light provides enormous difficulties for the photographic materials being used.  The photographer must learn techniques to alter the quality of light or risk loss of detail and information.

# Colour

The visible spectrum of light consists of a range of wavelengths from 400 nanometres (nm) to 700nm. Below 400nm is UV light and X-rays and above 700nm is infra red (all capable of being recorded on photographic film). When all the wavelengths of the visible spectrum are viewed simultaneously we see 'white light'. The broad spectrum of wavelengths creating white light can be divided into the three primary zones of colour: **Blue, Green and Red.**

The precise mixture of primary colours in white light may vary from different sources. The light is described as cool when predominantly blue, and warm when predominantly red. Human vision adapts to different mixes of white light and will not pick up the fact that a light source may be cool or warm unless it is compared directly with another in the same location.

The light from tungsten bulbs and firelight consists predominantly of light towards the red end of the spectrum. Daylight is a mixture of predominantly cool skylight and predominantly warm sunlight. Daylight colour film is balanced to give fairly neutral tones with noon summer sunlight. When the direct sunlight is obscured or diffused however the skylight can dominate and the tones record with a blue cast. As the sun gets lower in the sky the light gets progressively warmer and the tones will record with a yellow or orange cast. The colour of light can be measured by a scale called degrees kelvin (K). Daylight film is calibrated at 5500K. To control the colour of the final image the photographer has the option to either choose the time of day to create images or use photographic filters to reduce or remove the colour cast.

| Light Source | Colour temp. | Filter No. to correct cast |
|---|---|---|
| Shaded subject in sunlight | 8000K | 81EF |
| Overcast sky | 7000K | 81D |
| lightly overcast sky | 6000K | 81A |
| Summer sunlight | 5500K | No filter |
| Early morning/late afternoon sun | 3500K | 82C |
| Photoflood bulb | 3400K | 80B |
| Tungsten halogen lamps | 3200K | 80A |
| Household bulbs | 2800K | |
| Sunset | 2000K | |

# Direction

The direction of light decides where the shadows will fall and its source can be described by its relative position to the subject. The subject may be lit by a single light source or more than one. This additional light may be reflected back onto the subject from a nearby surface or may be shining directly onto the subject from a second light source.

The reason that many location photographs look flat and uninteresting is the photographer's poor choice of timing. By the time many photographers arrive at the location the sun is high, providing even illumination to the environment. The colours can look washed out as a result and there is little or no modelling of light and shade. The mood and atmosphere of a location can be greatly enhanced by the simple realisation that most successful location images are taken when the sun is low or as it breaks through cloud cover to give uneven and directional illumination to the environment below.

When the sun is high or diffused by cloud cover the mood and the subject contrast usually remains constant. With low sun the photographer can often choose a variety of moods by controlling the quantity and position of shadows within the image.

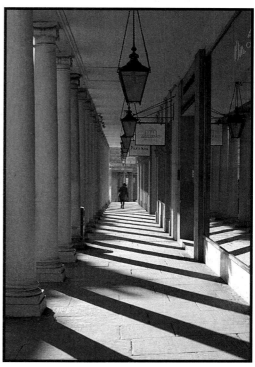

*Bath*

# Early and late light

Many photographers consider dawn and dusk prime times to be photographing. The colours are often rich and intense and the opportunities to shoot into the light and find broken light increase dramatically. Dawn in summer is especially useful as landscapes are often very still and the morning mist can increase the mood and atmosphere dramatically.

# Activity 2

Using one roll of colour transparency film visit the same location at dawn, midday and late afternoon/evening when the sun is low.

Take eight images at each of the three visits.

When the sun is low be sure to take images of the effect of the light on the location not just the light source itself.

Compare the colour and quality of light in the images and comment on the mood that is communicated.

# Contrast

Light is reflected unevenly off surfaces, light tones reflecting more light than dark tones. Each subject framed by the photographer will include a range of tones. The broader the range of tones the greater the contrast.

When harsh directional light such as sunlight strikes a subject the overall contrast of the scene increases. The tones facing the light source continue to reflect high percentages of the increased level of illumination whilst the shadows may reflect little extra. The overall contrast of the framed subject is called the '**subject brightness range**' or **SBR.**

*SBR of approximately four stops (16:1)*     *SBR of approximately three stops (8:1)*
*Jana Liebenstein*

# Brightness range

Subject brightness range. The SBR can be measured by taking a meter reading of the lightest and darkest tones. If the lightest tone reads f16 @1/125 second and the darkest tone reads f4 @ 1/125 second the difference is four stops or 16:1.

| Shadow tones | Mid-tones | Highlights |
| --- | --- | --- |

High SBR in flat light

⟵⟶

Extreme SBR in harsh directional light

⟵⟶

←── Latitude of positive film ──→

←─── Latitude of negative film ───→

*Increased exposure to capture shadow detail*

*Decreased exposure to capture highlight detail*

**A subject with a high or extreme brightness range can exceed the latitude of the film**

# Film latitude

Film is capable of recording a limited tonal range or brightness range. A subject photographed in high contrast lighting may exceed this recordable range. The ability for the film to accommodate a brightness range is referred to as its '**latitude**'.

Colour transparency film and colour prints have the ability to accommodate a brightness range of only 32:1 or five stops. Black and white prints will accommodate a brightness range of 128:1 or seven stops. It is essential for photographers to understand that when working in colour with directional sunlight, shadow and highlight detail may be lost. The photographer working in black and white has increased flexibility to capture a broader range of tones and with careful exposure, processing and printing techniques they can extend this range still further. See the chapter "**The Zone System**".

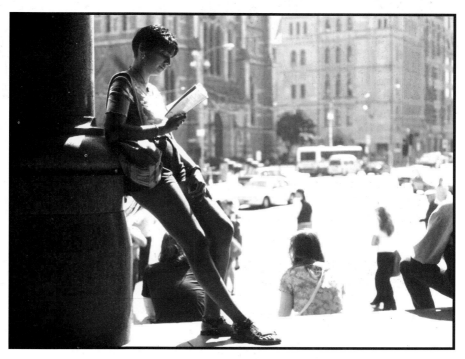

*SBR exceeding the latitude of the film*

# Previsualisation

Awareness of the subject brightness range and the capability of the photographic medium to capture this range of tones, allows the photographer to previsualise or predict the outcome of the final image. When the brightness range exceeds the film's capabilities the photographer has the option to increase or decrease exposure to protect shadow or highlight detail that would otherwise not record. These scenes are described as '**extreme contrast**'.

# Extreme contrast

In an attempt to previsualise the final outcome of a scene with a high brightness range, many photographers use the technique of squinting or narrowing the eyes to view the scene. This technique removes detail from shadows and makes the highlights stand out from the general scene. In this way the photographer is able to predict the contrast of the resulting image. If the photographer fails to take into account the film's limited capabilities both shadow detail and highlight detail can be lost. When working with black and white film photographers generally expose to protect shadow detail. With colour transparency work however the photographer generally avoids overexposing or bleaching the highlights leaving the clear film base.

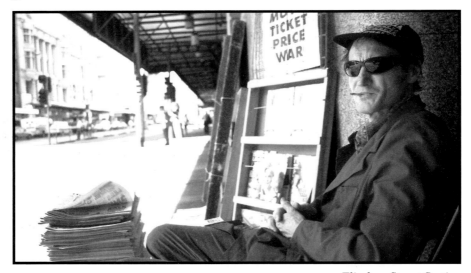

*Flinders Street Station*

In many instances when the photographer is expected to work quickly it is all the photographer can do to notice the extreme brightness range and make quick judgements from experience to alter the exposure. The least appropriate exposure in extreme contrast situations is often the exposure indicated by a camera's TTL meter. This average exposure may not be suitable if the subject or detail is located in the deep shadows or bright highlights. In these instances the photographer must override the exposure indicated by the meter and either open up (increase exposure) if shadow detail is required, or stop down (decrease exposure) if highlight detail is required.

In the photograph above the lighting contrast between the noon sun and the shadows was too great to record onto film. Increased exposure over the indicated meter reading was required to capture the shadow detail.

# Activity 3

Collect four images where the tonal range of the subject has exceeded the tonal range that can be recorded onto film. Indicate whether the exposure has been increased or decreased.

# Exposure compensation

Correct exposure compensation in high contrast situations is a skill that takes time to perfect. The results of exposure compensation are most easily viewed by using transparency film as different exposures are quickly assessed. The amount of compensation necessary will vary depending on the level of contrast present, what the photographer feels is most important to capture and the metering system being used by the camera, i.e. centre weighted, matrix, spot etc. Compensation is usually made in 1/3 or 1/2 stop increments but when a subject is backlit and TTL metering is used the exposure may need increasing by two or more stops depending on the lighting contrast. Remember that:

**Increasing exposure will reveal more detail in the shadows and dark tones**
**Decreasing exposure will reveal more detail in the highlights and bright tones**

## Exposure compensation dial

The use of an exposure compensation dial is required when the photographer wishes to continue working with an automatic metering system instead of using the manual controls. When using an automatic metering mode the photographer cannot simply adjust the exposure from that indicated by the meter using the aperture or shutter speed. The automatic mode will simply re-compensate for the adjustment.

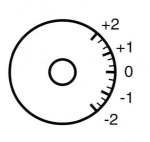 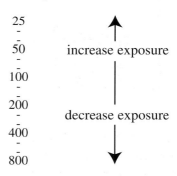

## Compensating by altering film speed

If the camera is not equipped with an exposure compensation dial, compensation may be achieved by altering the film speed. By decreasing the film speed from 100 ISO to 50 ISO the photographer will increase the exposure by one stop. By doubling the film speed the exposure will be decreased by one stop. Films are available in 1/3 stop increments so this allows compensation in 1/3 increments. The disadvantage using the film speed dial is that it is usually not as conveniently situated on the camera, may require an additional button to be depressed before it can be altered and there is usually no indication that compensation is being used in the viewfinder. Without this visual reminder that compensation is being used the photographer must return the film speed to the correct setting after each shot or they run the risk of compensating all subsequent shots whether they need it or not.

# Assessing the degree of compensation

Photographers calculate the degree of compensation in a variety of different ways. The method chosen is often dictated by whether speed or accuracy is the primary consideration.

**Bracketing** - The photographer can estimate the necessary compensation and bracket the exposures. To bracket the exposure the photographer must take several frames varying the exposure in 1/3 or 1/2 stop increments.

**Grey card reading** - Photographers can use a mid-tone of known value from which to take a reflected light meter reading. A mid-tone of 18% reflectance is used by photographers and is known as a 'Grey Card'. The grey card must fill the viewfinder and be placed at the same distance from the light source as the subject being photographed. There is no need to focus on the grey card to establish a light meter reading. The photographer must take care not to cast their own shadow and that of the camera on the grey card when taking the reading.
When using colour transparency or positive film the indicated exposure is suitable for a brightness range not exceeding five stops. If highlight or shadow detail is required with subjects exceeding the brightness range of the film the exposure must be adjusted accordingly.
When using black and white negative film the indicated exposure is suitable for a brightness range not exceeding seven stops. If the subject brightness range exceeds seven stops the exposure can be increased and the subsequent development time decreased.

**Caucasian skin** - When no grey card is available a commonly used mid-tone is the Caucasian skin. Caucasian skin placed in the light is approximately one stop lighter than the average mid-tone. A photographer with Caucasian skin can use this knowledge to take a reading from their own hand. If placed in the light the photographer can open up one stop after taking a reading. Further adjustments are necessary for an SBR exceeding the latitude of the film.

**Re-framing** - If the photographer is working quickly to record an unfolding event or activity they may have little or no time to bracket or take an average mid-tone reading. In these circumstances the photographer may take a reading quickly from a scene of average reflectance close to the intended subject. This technique of re-framing may also include moving closer to the primary subject matter in order to remove the light source and the dominant light or dark tones from the framed area. Many modern cameras feature an exposure lock to enable the photographer to find a suitable exposure from the environment and lock-off the metering system from new information as the camera is repositioned.

**Judgement** - The fastest technique for exposure compensation is that of judgement from experience and knowledge. This technique requires the photographer to estimate the necessary compensation as they view the scene to be photographed and previsualise the intended image. Compensation is set as the camera is raised to the eye. The photographer must remember to cancel the compensation as soon as a new lighting situation is encountered.

# Compensation for backlit subjects

The most common instance requiring exposure compensation is when the subject is backlit. The built-in metering system of a camera will be overly influenced by the light source and indicate a reduced exposure. The indicated exposure is further reduced as the light source occupies more and more of the central portion of the viewfinder. The required exposure for the subject may be many times greater than the indicated exposure.

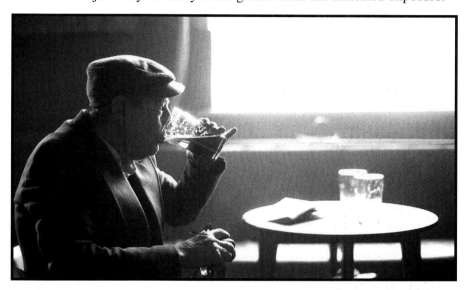

*The Rhondda*

If the camera that the photographer is using is in manual mode or equipped with an exposure lock, the photographer can meter for the specific tonal range required and then re-frame the shot. A popular alternative used by many professionals is to adjust the exposure using the exposure compensation dial. Using this technique the photographer can avoid re-framing after first metering.

# Activity 4

Load a 35mm SLR camera with medium speed transparency film.

Choose four different lighting situations where the subject is backlit.

Take a photograph of each subject with the 'meter indicated exposure' or MIE.

**Do not reposition the frame.** Make a record of the exposures.

Using your own judgement compensate the exposure using either the exposure compensation dial or film speed dial. Make a record of the exposures.

Take a meter reading for the shadow area and with the camera set to manual take one shot at this reading. Make a record of the exposure.

Take a meter reading for the highlight area and with the camera set to manual take one shot at this reading. Make a record of the exposure.

Process the roll of film and label the results of each frame.

# Extreme contrast and black and white film

With extreme contrast scenes exceeding seven stops (128:1) it is common practice when using black and white film to always increase exposure. Highlight detail is not sacrificed by this action if the processing time is reduced.

### Expose for the shadows

With standard processing of an overexposed negative the highlights would be very dense and difficult to print. This density is reduced in the processing by decreasing the development time by 15-30% per stop of increased exposure. The reduction in development time effects the highlight density more than the shadow detail and lowers the overall contrast of the negative

### Process for the highlights

Hence when using black and white it is generally advised that the photographer 'expose for the shadows and process for the highlights'.

---

# Summary of exposure compensation

## Dominant tones

The 'through the lens' (TTL) light meter in a 35mm SLR camera measures the level of reflected light from the subject in the framed image. The TTL meter does not measure the level of illumination from the light source (ambient light). The resulting exposure from the reflected light meter reading is an average between the light and dark tones present. When light and dark tones are of equal distribution within the frame this average light reading is suitable for exposing the subject. When light or dark tones predominate in the image area they overly influence the meter's reading and the photographer must increase or decrease exposure accordingly.

| Dominant light tones | increase exposure | + | Open up |
| Dominant dark tones | decrease exposure | – | Stop down |

## Extreme contrast

### Colour transparency

| Increase highlight detail | decrease exposure | – | Stop down |
| Increase shadow detail | increase exposure | + | Open up |

### Black and white negative

| SBR exceeding 128:1 | increase exposure/reduce development time |

# Creative techniques

Exposure compensation is used to correct tonal values that would otherwise have recorded too dark or too light. It is also used to record detail in highlights or shadows when the brightness range of the subject is high. The third reason exposure compensation is used is for creative effect.

## Colour saturation

By decreasing exposure by 1/3 or 2/3 of a stop, colours will appear more saturated or intense. The technique works well in flat midday light. Images can look underexposed however if the photographer is recording tones of known value.

## Silhouettes

An image described as a silhouette is the dark shadow or outline of the subject against a lighter background. A silhouette can be created by selecting a backlit subject and reducing the exposure sufficiently to remove detail from the subject. Reducing the appropriate exposure for the subject by approximately two stops is usually sufficient to record the subject as solid black.

*Temple of the Emerald Green Buddha, Bangkok*

## Activity 5

Create two silhouettes choosing a subject with an interesting profile.
One silhouette should have a white or clear background and the second should utilise the colours of an evening sky.
Bracket the reduced exposure compensation for each and label the results.

## Low key

A low key image is one where the dark tones dominate the photograph. Small bright highlights punctuate the shadow areas creating the characteristic mood of a low key image. The position of the light source for a typical low key image is behind the subject or behind and off to one side, so that the deep shadows are created. Highlights are created around the rim of the subject. The decision concerning appropriate exposure usually centres around how far the exposure can be reduced before the highlights appear dull. The shadow areas are usually devoid of detail when this action is taken unless a certain amount of fill is provided.

*Chengdu*

*High Key - Angela Nichols*

## High key

In a high key image the light tones dominate. Dark tones are eliminated or reduced by careful choice of the tonal range of the subject matter. Soft diffused light or lighting from the camera axis is used to reduce shadows. Backgrounds may be flooded with light so that little detail is seen. Increased exposure ensures that all the tones are predominantly light. Hard edges and fine detail may be reduced by the use of a soft focus filter. A bright background placed close to the subject may also soften the outline of the form. The main light source to illuminate the subject can be provided by skylight, window light, reflected light or flash. Backgrounds can be overexposed or blown by sunlight.

## Activity 6

Create one high key and one low key image.
Describe the lighting used for each image including a record of the indicated exposure and degree of compensation.

# Revision exercise

Q1.   A subject two metres from the sole light source is correctly exposed at 1/60 second @ f5.6.  The subject moves to a new position four metres from the light source. What would the new exposure be if the level of light remains constant?

Q2.   A subject in harsh sunlight has dark shadows.  Discuss how the light can be softened to produce acceptable results with both shadow and highlight detail.

Q3.   What filter could a photographer use to remove the colour cast on a lightly overcast day using daylight transparency film?

Q4.   If the MIE of the darkest shadow tone reads f4 and the brightest highlight reads f16, what is the subject brightness range or SBR?

Q5.   What degree of exposure compensation would you expect to have to use when photographing somebody backlit by the sun?

Q6.   A photographer uses Caucasian skin to establish an exposure reading for a mid-tone.  What adjustment should be made to the meter-indicated exposure to correctly expose for the mid-tone?

Q7.   Describe the steps necessary to create a silhouette, a low key and a high key image.

# Resources

*Basic Photography - Michael Langford.*  Focal Press.  London.  1997.
*Black and White Photography - Rand/Litschel.*  West Publishing Co. Minneapolis. 1994.
*Encyclopedia of Photography.*  Crown Publishers.  New York.  1984.
*Photography - London and Upton.*  Harper Collins College Publishers.  New York.  1994.
*Photographic Lighting - Child/Galer.*  Focal Press.  London.  1999.
*The Complete Photographer - Gus Wylie.*  Pyramid Books.  London.  1989.
*The Focal Encyclopedia of Photography.*  Focal Press.  London.  1993.

# Gallery

*Lee Rosperich*

*Michael Wennrich*

*Joanne Gamvros*

# Lighting on Location

*Mark Galer*

## Aims

~ To develop knowledge and understanding of how light can change the character and mood of subject matter.

~ To develop an awareness of overall subject contrast and how this translates to photographic film.

~ To develop skills in controlling introduced lighting on location.

## Objectives

~ **Research** - Produce research in your visual diary that looks at a broad range of fill and flash lighting techniques.

~ **Discussion** - Exchange ideas and opinions with other students on the work you are studying.

~ **Practical work** - Produce photographic positives through close observation and selection that demonstrate how lighting techniques control communication.

# Introduction

The lighting in a particular location at any given time may not be conducive to the effect the photographer wishes to capture and the mood they wish to communicate.  In these instances the photographer has to introduce additional lighting to modify or manipulate the ambient light present.  In some instances the ambient light becomes secondary to the introduced light or plays little or no part in the overall illumination of the subject.  The following conditions may lead a photographer towards selecting additional lighting:

~   The lighting may be too dull for the intended film and the resulting slow shutter speeds would cause either camera shake or subject blur.
~   Colour temperature of artificial lights causing undesired colour casts.
~   The ambient light is leading to an unsuitable brightness range for the film, e.g. the contrast is too high for the latitude of the film and would lead to either overexposed highlights or underexposed shadows.
~   The direction of the primary light source is giving unsuitable modelling for the subject, e.g. overhead lighting creating unsuitable shadows on a models face.

*St. Kilda market*

# Activity 1

Select four images created on location where you feel the photographer has used additional lighting to the ambient light present.

Discuss how and why you think the lighting has been changed to suit the communication.

# Fill

In high and extreme contrast scenes where the subject brightness range exceeds the latitude of the film it is possible for the photographer to lower the overall lighting ratio by supplying additional fill-light.  The two most popular techniques include using reflectors to bounce the harsh light source back towards the shadows or by the use of on-camera flash at reduced power output.  Before the photographer jumps to the conclusion that all subjects illuminated by direct sunlight require fill, the photographer must first assess each scene for its actual brightness range.  There can be no formula for assessing the degree of fill required when the subject is illuminated by direct sunlight.  Formulas do not allow for random factors which are present in some situations but not in others.  Photographers must, by experience, learn to judge a scene by its true tonal values and lighting intensity.

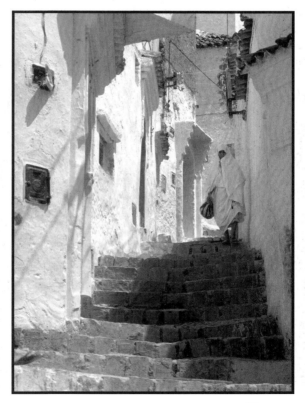

*Morocco*

The photograph above was taken in Morocco in harsh sunlight.  The photographer could be mistaken for presuming this is a typical scene which would require fill light.  If the scene is read carefully however the photographer would realise that the shadows are not as dark as one would presume.  Meter readings taken in the shadows and highlights would reveal that the shadows are being filled by reflected light from the brightly painted walls.

# Reflectors

Fill-light can occur naturally by light bouncing off reflective surfaces within the scene.  It can also be introduced by reflectors strategically placed by the photographer.   This technique is often used to soften the harsh shadows cast on models in harsh sunlight. The primary considerations for selecting a reflector are surface quality and size.

## Surface quality

Reflectors can be matt white, silver or gold depending on the characteristics and colour of light required.  A matt white surface provides diffused fill light whilst shiny surfaces, such as silver or gold, provide harsher and brighter fill light.  Choosing a gold reflector will increase the warmth of the fill light and remove the blue cast present in shadows created by sunlight.

## Size

Large areas to be filled require large reflectors.  The popular range of reflectors available for photographers are collapsible and can be transported to the location in a carrying bag. A reflector requires a photographer's assistant to position the reflector for maximum effect.

Beyond a certain size (the assistant's ability to hold onto the reflector on a windy day) reflectors are often not practical on location.

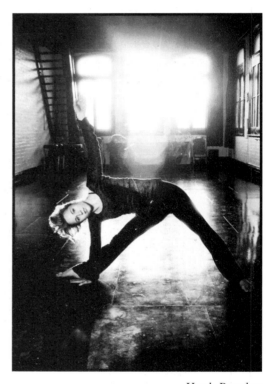

*Hugh Peachey*

# Activity 2

Select four examples where fill light has been used to soften the shadows created by a harsh, direct light source.

Comment on the likely source of the fill light.

Create two images using different reflectors to obtain different qualities of fill light.

# Flash

Flash is the term given for a pulse of very bright light of exceptionally short duration. The light emitted from a photographic flash unit is balanced for daylight film and the duration of the flash is usually shorter than 1/500 second.

When the photographer requires additional light to supplement the daylight present, flash is the most common source used by professional photographers. Although it can be used to great effect it is often seen as an incredibly difficult skill to master. It is perhaps the most common skill to remain elusive to students of photography when working on location. The difficulty of mastering this essential skill arises in the fact that the effects of the flash are not seen until the film is processed. The flash is of such short duration that integrating flash with ambient light is a skill of previsualisation and applied technique. The photographer is unable to make use of modelling lights that are used on studio flash units (modelling lights that can compete with the sun are not currently available). The skill is therefore mastered by a sound understanding of the characteristics of flash light and experience through repeated application.

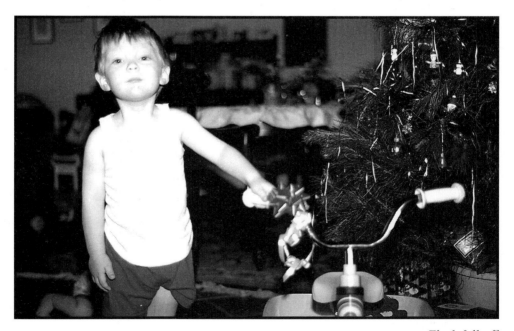

*Flash fall-off*

## Characteristics

Flash is a point light source used relatively close to the subject. The resulting light is very harsh and the effects of fall-off (see "Characteristics of Light") are often extreme. One of the skills of mastering flash photography is dealing with and disguising these characteristics that are often seen as professionally unacceptable.

# Choice of flash

Choosing a flash unit for use on location may be decided on the basis of degree of sophistication, power, size and cost.

Most commercially available flash units are able to read the reflected light from their own flash during exposure.  This feature allows the unit to extinguish or 'quench' the flash by a **'thyristor'** switch when the subject has been sufficiently exposed.  When using a unit capable of quenching its flash, subject distance does not have to be accurate as the duration of the flash is altered to suit.  This allows the subject distance to vary within a given range without the photographer having to change the aperture set on the camera lens or the flash output.  These sophisticated units are described as either **'automatic'** or **'dedicated'**.

ISO scale

Aperture scale

Distance range

Power setting

*Control panel of an older style automatic flash unit*

## Automatic

An automatic flash unit uses a photocell mounted on the front of the unit to read the reflected light and operate an on-off switch of the fast acting thyristor type.  The metering system works independently of the camera's own metering system.  If the flash unit is detached from the camera the photocell must remain pointing at the subject if the exposure is to be accurate.

## Useful specifications

Perhaps the most important consideration when selecting an automatic flash unit is its ability to make use of a range of f-stops on the camera lens.  Cheaper units may only have a choice of two f-stops whereas more sophisticated units will make use of at least four.

Ideally the output of a professional unit will have a **'guide number'** (an indication of the light output) of 25 or more.  The amount of time the unit takes to recharge is also a consideration.  Many flash outfits have the option of being linked to a separate power pack so that the drain on the units smaller power supply (usually AA batteries) does not become a problem.

The flash head of a unit will ideally swivel and tilt allowing the photographer to direct the flash at any white surface whilst still keeping the photocell pointed at the subject.

# Dedicated

Dedicated flash units are often designed to work with specific cameras, e.g. Nikon 'speedlights' with Nikon cameras. The camera and flash communicate more information through additional electrical contacts in the mounting bracket of the unit. The TTL metering system of the camera is used to make the exposure reading instead of the photocell. In this way the exposure is more precise and allows the photographer the flexibility of using filters without having to alter the settings of the flash.

In addition to the TTL metering system, the camera may communicate information such as film speed and the focal length of the lens being used. This information may be automatically set ensuring an accurate exposure and the correct spread of light.

Features such as automatic fill flash, slow sync, rear curtain slow sync, red eye reduction and strobe are common features of some sophisticated units. Often the manuals accompanying these units are as weighty as the manual for the camera which they are designed to work in conjunction with.

Film speed

Focal length

TTL indicator

Distance range
Selected aperture

*Control panel of a modern dedicated flash unit*

# Setting up a flash unit

- Check that the film's ISO has been set on the flash/flash meter and camera.
- Check that the flash is set to the same focal length as the lens. This may involve adjusting the head of the flash to ensure the correct spread of light.
- Check that the shutter speed on the camera is set to the correct speed (usually slower than 1/125 second on a 35mm SLR camera using a focal plane shutter).
- Check that the aperture on the camera lens matches that indicated on the flash unit.
- On dedicated units you may be required to set the aperture to an automatic position or the smallest aperture.
- Check that the subject is within range of the flash. On dedicated and automatic units the flash will only illuminate the subject correctly if the subject is within the two given distances indicated on the flash unit. If the flash is set incorrectly the subject may be overexposed if too close and underexposed if too far away.
- Check the accuracy of the flash output using a flash meter (see "Guide numbers" in this study guide).

# Guide numbers

Portable flash units designed to be used with small-format and medium-format cameras are given a **'guide number'** (**GN**) by the manufacturers.  This denotes its potential power output.  The guide number is an indication of the maximum distance at which the unit can be used from the subject to obtain an appropriate exposure.  The guide number is rated in metres using a 100 ISO film and an aperture of f1.  Because very few photographers possess an f1 lens the actual maximum working distance is usually somewhat lower than the guide number would suggest.

A unit given a guide number of thirty-two could correctly expose a subject at sixteen metres using an aperture of f2 (32 divided by 2 = 16).  If the lens was changed to one with a maximum aperture of f4, the maximum working distance would be reduced to eight metres.

It therefore follows that if the guide number of the unit is known the correct exposure can be determined by dividing the guide number by the working distance.  The resulting figure is the aperture required when the flash is turned to manual full power (photocell effectively switched off).  For example a flash with a guide number of thirty-two used to expose a subject four metres away will require an aperture of f8.

---

**Distance from subject ✕ indicated aperture (MIE) = Guide number**

**Guide number    ÷    aperture = Effective working distance**

**Guide number   ÷    distance from subject = Correct aperture**

---

# Activity 3

Test the guide number of a flash unit using a hand-held flash meter.  The unit does not have to be attached to a camera.

Turn the flash unit to manual operation and full power.

Stand a measured distance from the flash unit e.g. four metres.

Attach an invercone to the flash meter's cell and set the film speed to 100 ISO.

Aim the flash meter at the unit and take an ambient reading of the flash (use a 'sync lead' or friend to manually trigger the flash using the test button).

Multiply the indicated aperture on the flash meter by the distance used, e.g. if the subject stands four metres from the flash and records a meter reading of f11 the guide number of the unit is 44.

# Flash as the primary light source

The direct use of flash as a professional light source is often seen as unacceptable due to its harsh qualities. The light creates dark shadows that border the subject, hot spots in the image where the flash is directed back into the lens from reflective surfaces and 'red-eye'.

## Red-eye

Red-eye is produced by illuminating the blood-filled retinas at the back of the subject's eyes with direct flash. The effect can be reduced by exposing the subjects eyes to a bright light prior to exposure ('red-eye reduction') or by increasing the angle between the subject, the camera lens and the flash unit. Red-eye is eliminated by moving closer or by increasing the distance of the flash unit from the camera lens. To do this the lens must be removed from the camera's hot-shoe. This is called **'off-camera flash'**.

## Off-camera flash

Raising the flash unit above the camera has two advantages. The problem of red eye is mostly eliminated. Shadows from the subject are also less noticeable.

When the flash unit is removed from the camera's hot shoe the flash is no longer synchronised with the opening of the shutter. In order for this synchronisation to be maintained the camera and the flash need to be connected via a 'sync lead'.

For cameras that do not have a socket that will accept a sync lead a unit can be purchased which converts the hot shoe on the camera to a sync lead socket. If a dedicated flash unit is intended to be used in the dedicated mode a dedicated sync cable is required that communicates all the information between the flash and the camera. If this is unavailable the unit must be switched to either automatic or manual mode.

**Keep the photocell of an automatic unit directed towards subject during exposure.**

## Hot-spots

When working with direct flash the photographer should be aware of highly polished surfaces such as glass, mirrors, polished metal and wood. Standing at right angles to these surfaces will cause the flash to be directed back towards the cameras lens creating a hot-spot. Whenever such a surface is encountered the photographer should move so that the flash is angled away from the camera. It is a little like playing billiards with light.

# Activity 4

Connect a flash unit to your camera via a sync lead and set the unit to automatic.
Position a fellow student or friend close (within half a metre) to a white wall.
Hold the flash above the camera and expose several frames using colour transparency film at varying distances from the subject.
Repeat the exercise with the unit mounted on-camera.
Discuss the results commenting on the shadows and the presence of red-eye.

# Diffusion and bounce

If the subject is close or the output of the flash unit is high, the photographer has the option of diffusing or bouncing the flash.  This technique will soften the quality of the light but lower the maximum working distance.

## Diffusion

Diffusion is affected by placing tissue, frosted plastic or a handkerchief over the flash head.  Intensity of light is lowered but the quality of light is improved.

The flash can be further diffused by directing the flash towards a large, white piece of card attached to the flash head.  Purpose-made attachments can be purchased.

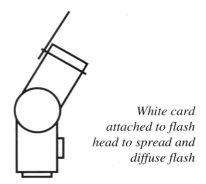

*White card attached to flash head to spread and diffuse flash*

## Bounce flash

The most subtle use of flash is achieved by directing the flash to a much larger, white reflective surface such as a ceiling for overhead lighting, or nearby wall for side lighting.  This is called bouncing the flash.  To obtain this effect the flash unit must have the ability to tilt or swivel its flash head.  If this is not possible the flash can be removed from the hot shoe and connected to the camera via a sync lead.  If an automatic flash is being used the photographer must ensure that the photocell is facing the subject when the flash is fired.

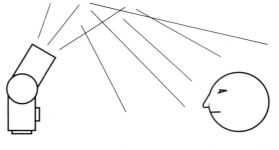

*Bounce flash*

## Activity 5

Use another student or friend holding the flash meter as your subject.
Diffuse the flash and record the adjusted GN of the unit.
Expose two frames compensating for the reduced intensity of the flash.
Expose four frames of film using bounce flash at two different distances to the subject.
Bounce the flash off a white ceiling or white reflector positioned to one side of the subject.
Compare the quality of the light in the images produced above.

# Fill-flash

Fill-flash can be a very useful way of lowering the brightness range. Often the photographer is unable to reposition the primary subject and the addition of fill light from the camera's position is essential to the image's success.

The aim of fill-flash is to reveal detail in the dark shadows created by a harsh directional light source. The aim is not to overpower the existing ambient light and remove the shadows completely. If the power of the flash is too high the light will create its own shadows creating an unnatural effect. Because the ambient light is still regarded as the primary light source any exposure dictated by the flash unit must also be suitable for the ambient light. To retain the effect of the primary (ambient) light source the flash is most commonly fired at half or quarter power. The ratio of ambient to flash light is therefore 2:1 or 4:1.

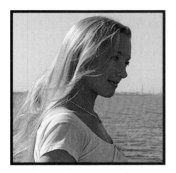
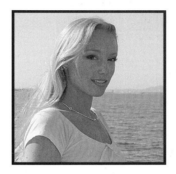

*Ambient light only*                 *4:1 ratio*                         *1:1 ratio*
                                                                    *Angela Nichols*

**Manual** - Select a smaller aperture on the camera from that indicated by the flash unit or flash meter, e.g. if the meter or unit indicates f5.6 select f8 or f11 on the camera.

**Automatic** - Many automatic flash units have the facility to fire at 1/2 or 1/4 power making fill-flash a relatively simple procedure. If this facility is unavailable set the film speed on the flash unit to double or quadruple the actual speed of the film to lower the output.

**Dedicated** - Many sophisticated cameras and dedicated flash units have a fill-flash option. This should be regarded as a starting point only and further adjustments are usually required to perfect the technique. Power often needs to be further lowered for a more subtle fill-in technique. The photographer may also wish to select a **'slow-sync'** option on the camera, if available, to avoid underexposing the ambient light in some situations.

# Activity 6

Lower the lighting contrast of a portrait lit with harsh sunlight using fill-flash.

Illuminate the subject from above, from the side and from the back.

Take three images for each lighting scenario setting the flash unit to full power, half power and quarter power.

Label the results and discuss the most favourable fill/ambient lighting ratio of each image.

# Flash as a key light

The main light in studio photography is often referred to as the **'key light'**.  Using studio techniques on location is popular in advertising and corporate photography where mood is created rather than accepted.  In this instance flash becomes the dominant light source and the ambient light serves only as the fill light.

When the ambient light is flat directional light can be provided by off-camera flash.  This enables the photographer to create alternative moods.  The use of off-camera flash requires either the use of a **'sync lead'** or an infrared transmitting device on the camera.

## Slave units

Some professional flash units come equipped with a light-sensitive trigger so that as soon as a flash that is connected to the camera is fired the unconnected flash or **'slave'** unit responds.  On location the slave unit can be fired by the use of a low powered on-camera flash.

## Accessories

A tripod or assistant is required to either secure or direct the flash.

An umbrella or alternative means of diffusion for the flash may be considered.

Colour compensating filters may also be considered for using over the flash head.  A warming filter from the 81 series may be useful to create the warming effect of low sunlight.

## Technique

- Check the maximum working distance of the flash.
- Ensure the key light is concealed within the image or out of frame.
- Diffuse or bounce the key light where possible.
- Consider the effects of fall-off.
- Avoid positioning the key light too close.
- Establish a lighting ratio between the key light and ambient light.
- Consider the direction of shadows being cast from the key light.

When working at night the photographer may have the option of approaching the subject and firing a number of flashes manually during an extended exposure (recharging the unit each time).  The photographer or assistant must take care not to illuminate themselves during this process.

## Activity 7

Take six images using flash as a directional key light.

Record the subject using three different lighting ratios.

# Slow-sync flash

Slow-sync flash is a technique where the freezing effect of the flash is mixed with a long ambient light exposure to create an image which is both sharp and blurred at the same time. Many modern cameras offer slow-sync flash as an option within the flash programme but the effect can be achieved on any camera. The camera can be in semi-automatic or manual exposure mode. A shutter and aperture combination is needed that will result in subject blur and correct exposure of the ambient light and flash. To darken the background so that the frozen subject stands out more, the shutter speed can be increased over that recommended by the camera's light meter.

~ Load the camera with 100 ISO film or less.
~ Select a slow shutter speed that will allow camera movement-blur (try experimenting with speeds around 1/8 second).
~ Take an ambient light meter reading and select the correct aperture.
~ Set the flash unit to give a full exposure at the selected aperture.
~ Pan or jiggle the camera during the long exposure.

*Emu*

## Possible difficulties

**Limited choice of apertures** - Less expensive automatic flash units can dictate the use of a limited choice of apertures. This can lead to a difficulty in obtaining the suitable exposure. More sophisticated units allow a broader choice of apertures, making the task of matching both exposures much simpler.

**Ambient light too bright** - If the photographer is unable to slow the shutter speed down sufficiently to create blur, a slower film should be used or the image created when the level of light is lower.

# Revision exercise

Q1.    State two reasons why you would choose to use a gold reflector on location whilst photographing a model on a sunny day.

Q2.    Describe the likely effect that you would see in the final image if you exceeded the recommended shutter speed whilst using flash on a 35mm SLR camera.

Q3.    A flash unit is switched to manual and fired at full power.  The flash meter reading taken six metres away indicates an exposure of f5.6.  What is the guide number of the flash unit?

Q4.    A flash unit with a guide number of thirty-six is switched to manual and fired at full power.  The distance to the subject is six metres and the photographer is using 400 ISO film.  What is the aperture required for a correct exposure?

Q5.    Describe how a photographer can reduce or eliminate the risk of red-eye?

Q6.    Explain the procedure you would need to take when lowering the SBR using an automatic flash unit?

Q7.    Explain the technique of using flash as a directional key light.

Q8.    An ambient reading at a location is metered as f8 @ 1/60 second using 200 ISO film.  It is decided to apply the technique of flash blur to the subject and that 1/8 second would be appropriate for the blur.  Describe the adjustments to the ambient exposure and the necessary flash exposure to create the required effect?

# Resources

*Basic Photography - Michael Langford.*  Focal Press.  London.  1997
*Black and White Photography - Rand/Litschel.*  West Publishing Co.  Minneapolis.  1994
*Encyclopedia of Photography.*  Crown Publishers.  New York.  1984.
*Photography - London and Upton.*  Harper Collins College Publishers.  New York.  1994.
*The Focal Encyclopedia of Photography.*  Focal Press.  London.  1993.

# Gallery

*Michael Davies*

*Michael Davies*

# Gallery

*Michael Mullan*

*Dianna Snape*

# The Zone System

*Canyon - Mark Galer*

## Aims

~ To increase knowledge and understanding concerning subject brightness range.
~ To increase control over the resulting tonal range of a black and white image.
~ To increase ability to previsualise the final printed image when viewing a scene.

## Objectives

~ **Research** - Photographic images created utilising the zone system.
~ **Discussion** - Exchange information and understanding with other students.
~ **Practical work** - Test the exposure index of the film you are using.
  Test the accuracy of the development you are using.
  Create images exposing for the shadows and processing for the highlights.

# Introduction

The zone system is a technique of careful metering, exposure, processing and printing designed to give maximum control over the resulting tonal values of a black and white image. It is an appropriate technique to use on location where the ambient light cannot be altered to suit the contrast and tonal range desired by the photographer. The system was developed by the famous landscape photographer Ansel Adams. He formulated that just as an octave of audio frequency can be subdivided into notes from A to G#, the tonal range of the image (from black to white) can also be subdivided into tones or zones, each zone being one stop lighter or darker than the next.

The zones on the photographic paper can be measured and are not open to interpretation. The zone system can however be used to interpret the subject differently depending on the desired outcome by the photographer. The photographer achieves this by choosing how dark or light the highlight and shadows tones will appear in the final printed image. **'Previsualisation'** is the term given to the skill of being able to see in the mind's eye the tonal range of the final print whilst viewing the subject. The zone system removes any surprise factor involved in the resulting tonal range of the image.

*Arches - Ansel Adams*

## Benefits and limitations

With practice the photographer needs only to take one exposure to translate the subject into a preconceived image. Ansel Adams did not bracket his exposures. He did not need to. He knew precisely the result that each exposure would produce.

The time it takes to meter the subject carefully limits the use of the system. Images are created using the zone system, not captured. Henri Cartier-Bresson would not have found Ansel's zone system very useful for the images he wished to make.

# Zone placement

Many photographers already use one aspect of the zone system when they take a light meter reading. Taking a reflected meter reading from a grey card and exposing the film to that meter indicated exposure, is to place a tone (middle grey) to a specific zone (Zone V). The placing of a tone to a specific zone is called **'zone placement'**.

To use the zone system fully the photographer must take **two** readings when metering the subject. One reading is taken from a highlight and one from a shadow. They are chosen by the photographer as the brightest and darkest tones which will require detail when these tones are viewed in the final image. These tones are selected subjectively. Each photographer may choose different highlight or shadow tones depending on the desired outcome. The selected highlight and shadow tones are then placed to appropriate zones.

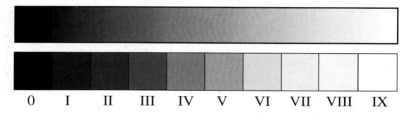

*The zone ruler*

The tonal range of the print is of course much greater than just ten tones. Breaking the tonal range into ten precise zones allows the photographer to visualise how a metered tone in the subject will translate into a tone on the printing paper.

A selected tone can be moved up or down the scale one zone at a time simply by opening or closing the aperture one stop at a time. By placing a tone further up or down the scale the image is made darker or lighter as all other tones are moved in the same direction.

## Activity 1

Frame a location (one that you can revisit again easily) when it is illuminated by directional sunlight. Approach a broad range of tones, from bright highlights to dark shadows, within the framed image and take a reflected light meter reading from each.

Keep a record of each tone and its meter indicated exposure.

Take a grey card reading and bracket three exposures (meter indicated exposure, plus one stop and minus one stop). Process the film **normally** using the manufacturer's recommended development time, temperature and frequency of agitation.

Make a print from each of the three negatives without burning the highlights or dodging the shadows on medium contrast printing paper.

Using your notes label the range of tones you metered for in the first step of this activity, e.g. you may label a dark tone f4 @ 1/125 second and a highlight as f16 @ 1/125 second. Discuss the tonal quality of each print with other students, e.g. can you see detail in the highlights and shadows?

# Contrast control

The individual tones within the subject can be moved closer together (lowering the contrast) by reducing the processing time, or moved further apart (increasing the contrast) by increasing the processing time. Decreasing the processing time decreases the density of the highlights on the negative whilst leaving the shadow tones relatively unaffected. Increasing the processing time increases the density of the highlight tones on the negative whilst leaving the shadow tones relatively unaffected. There is some effect on the mid-tones in both instances but proportionally less than the highlights.

If shadows are missing from the negative (areas of clear film base within the frame) then no amount of extra development will reveal detail in these areas.

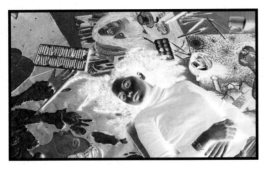    

*Negative with good detail*        *Contrast exceeding the latitude of the film*

## Subject brightness range

The photographer can measure the contrast of the subject (subject brightness range) and then alter the processing of the negatives according to the desired contrast. The photographer exercises precise control by measuring the distance in stops between a highlight tone and shadow tone. If the distance between the selected highlight and shadow tones is greater than four stops (extreme contrast) processing can be decreased to lower the contrast of the image. If the distance between the selected highlight and shadow tones is less than four stops the processing can be increased to increase the contrast of the image.

## Summary so far

- The zone system is made up of ten major tones from black to white.
- . Each tone is one stop darker or lighter than the next.
- Specific highlight and shadow tones of the subject are assigned to specific zones.
- Zone placement of a shadow tone is a subjective decision. The decision dictates what detail is visible and how dark these shadows appear in the final image.
- Development affects highlight tones proportionally more than shadow tones.
- Increased or decreased processing time leads to increased or decreased contrast.
- Subject contrast is measured in stops.
- Shadow tones are controlled by exposure and highlight tones by development.

# The zones

Each zone in the final image can be identified by its tone and the detail it reveals.
To obtain accuracy we must become familiar with the characteristics of each zone.

Zone XI. Paper white. The standard print utilising a full tonal range uses little or no paper white in the image.

Zone VIII. White without detail. The brightest highlights in the image are usually printed to this zone.

Zone VII. Bright highlights with visible detail or texture. If highlight detail is required it is placed in this zone by calculated processing time.

Zone VI. Light grey. Caucasian skin facing the light source is usually printed as Zone VI.

Zone V. Mid-grey with 18% reflectance. A meter indicated exposure from a single tone will produce this tone as a Zone V on the negative.

Zone IV. Dark grey.
Shadows on Caucasian skin are usually printed as Zone IV.

Zone III. Dark shadow with full detail and texture. If shadow detail is required it is placed in this zone by calculated exposure.

Zone II.
Shadow without detail.

Zone I.
Black.

Zone O.
Maximum black and is indistinguishable from Zone I in the printed image.

# Activity 2

Refer back to the three prints created for Activity 1.
Select the image with the broadest range of tones (best exposure).
Label this image with the zones from I to IX. Use the description of each zone on this page to help you identify each zone.
Compare and discuss your labelled image with those of other students.

# Zone recognition

Using the description in the previous section we are now able to recognise what each zone looks like in the printed image. Zones III and VII are of particular interest as they will indicate the accuracy of how a photographer has utilised the zone system. Important areas of shadow and highlight detail will have been preserved whilst still utilising Zones II and VIII to give the print both depth and volume.

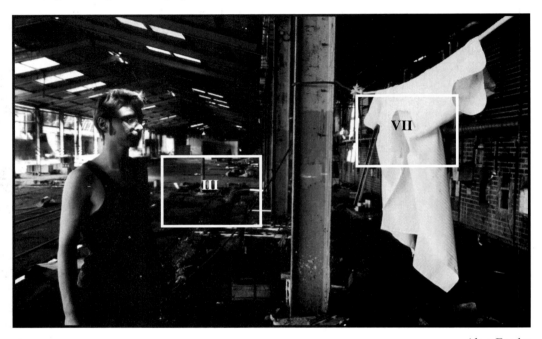

*Alan Fredes*

**Zone III**
Dark shadow with full detail and texture. If shadow detail is required it is placed in this zone by calculated exposure.

**Zone VII**
Bright highlights with visible detail or texture. If highlight detail is required it is placed in this zone by calculated processing time.

# Operating the system

Gaining maximum control over the system requires practice. The student should take notes and compare the results with the actions taken. Mistakes may be made initially but these mistakes will lead to a greater understanding of the system.

Testing the accuracy of exposure and negative processing is crucial to obtaining precise control over the zone system. The photographer is advised to limit the combined choice of camera, light meter, film, developer, enlarger and printing paper until this control has been achieved, otherwise variations in outcome are inevitable.

*Jana Liebenstein*

## Choice of camera, light meter and film

Use a camera and a light meter that provide accurate exposures. If the camera or meter receives a shock through impact, the equipment should be checked. Some retail outlets will offer to test the accuracy of the equipment.

Select only one type of 100 ISO film until control has been achieved. The student should ideally have some experience of processing this film prior to using it for the zone system. Establish an **'exposure index'** for the film (see activity below). The usable speed for the film may vary from the manufacturers recommended speed due to variety of reasons.

## Activity 3

Using black and white negative film, take several exposures of a subject with a four stop range. Someone wearing a white shirt with dark trousers or jacket would be ideal. Calibrate the exposure using a reflected light meter reading taken from a grey card. The subject should be illuminated with diffused light (cloud cover or shade).

Bracket the exposures (1/3 stop intervals) keeping a precise record of each frame.

Process the negatives according to the manufacturer's specifications.

View the negatives on a light box and choose the best exposure with the assistance of an experienced practitioner. The darkest tones of the subject should render full texture and detail (no area of the image should appear clear).

Choose the best exposure and check your records to find the degree of compensation required. For example if the best exposures for accurately rendering shadow detail is 2/3 stop more than the manufacturer's recommendation of 100 ISO then proceed to rate the film at 2/3 stop less i.e. 64 ISO.

# Exposure and processing

The zone system can be approached in a series of sequential steps. The entire system can be divided into two main practical skills. These are:

~    **Exposing for the shadows.**
~    **Processing for the highlights.**

## Exposing for the shadows

1. View the subject and choose the dark shadows that you want to be able to see full detail and texture in when you view the final image. Take a specific reflected light meter reading from one of these dark shadow tones. Use a hand-held meter at close range or fill the frame of a 35mm SLR with the selected tone. Use a spot meter to isolate a tone from a distance.

2. Place the shadow tone in Zone III by stopping down two stops from your meter indicated exposure or MIE (e.g. if the light meter reading of the shadow tone is f4 @ 1/125 second then the final exposure could be f8 @ 1/125 second). This action is called 'exposing for the shadows'.

*Note: The original meter reading is often taken in the form of an 'EV' (exposure value) reading so that the final exposure can be interpreted by different combinations of aperture and shutter speed.*

*Metering for the shadows and processing for the highlights*

## Processing for the highlights

1. View the subject and choose the bright highlights that you want to be able to see full detail and texture in when you view the final image. Take a specific reflected light meter reading from one of these bright highlights. Measure how many stops brighter the highlights are than the shadows metered for in the previous step. If the shadow tone meter reading was f4 @ 1/125 the highlight tone may measure f16 @ 1/125 (four stops difference).

2. For bright highlights to record as bright highlights with full detail and texture they must fall in Zone VII (four stops brighter than the shadows). If this is the case the negatives can be processed normally. If the highlights measure more or less than four stops, decrease or increase processing time accordingly (see **"Compression"** and **"Expansion"**).

# Adjusting the development time

It is recommended that '**one shot**' development (tank development using freshly prepared developer which is discarded after the film is processed) is used in conjunction with a standard developer. Developers such as **D-76** and **ID-11** are ideal for this test.

The student should use the same thermometer of known accuracy (check it periodically with several others) and adhere to the recommended development times, temperatures and agitation. A pre-wash is recommended to maintain consistency.

**Viewing the negatives** – The highlights of a high contrast subject should be dark but not dense when the negatives are viewed on a light box. Newspaper print slid underneath the negatives should easily be read through the darkest tones of the image. Manufacturers numbers and identifying marks on pre-loaded film should appear dark but not swollen or 'woolly'. The student should view the negatives in the presence of an experienced practitioner to obtain feedback.

## Compression

If the selected highlights measure five or six stops brighter than the shadows placed in Zone III they will fall in Zone VIII or IX respectively. No detail will be visible by processing and printing the negative normally. The highlight tones selected can be moved one or two zones down the scale to Zone VII by decreasing the processing time. This situation is often experienced with a high to extreme subject brightness range (SBR).

Moving the highlights one zone down the scale is referred to as **N−1**, moving the highlights two zones down the scale is referred to as **N−2**. N−1 negatives are processed for approximately 85% of the normal processing time, N−2 negatives for approximately 75% of the normal processing time when using 100 ISO film. The action of moving highlight tones down the zone scale is called '**compaction**' or '**compression**'. Shadow tones remain largely unaffected by reduced processing time so the final effect is to lower the contrast of the final negative.

## Expansion

If the selected highlights measure only two or three stops brighter than the shadows they will fall in Zone V or VI respectively. Highlights will appear dull or grey if the negatives are processed and printed normally. The highlight tones selected can be moved one or two zones up the scale to Zone VII by increasing the processing time. This situation is often experienced with a low SBR or flat light.

Moving the highlights one zone up the scale is referred to as **N+1**, moving the highlights two zones up the scale is referred to as **N+2**. N+1 negatives are processed for approximately 130% of the normal processing time, N+2 negatives for approximately 150% of the normal processing time when using 100 ISO film. The action of moving highlight tones up the zone scale is called '**expansion**'. Shadow tones remain largely unaffected by increasing the processing time so the final effect is to increase the contrast of the final negative.

# Calibration tests

The following additional tests can be conducted to check the accuracy of exposure and processing time.

*Note: Changing printing papers or type of enlarger (diffusion or condenser) will change the tonal range and contrast that can be expected and so therefore should be avoided.*

## Exposure

The exposure index is calibrated by checking the accuracy of shadow tones on the negative. This can be achieved by using a **'densitometer'** or by conducting the following clip test.

- ~ Underexpose a grey card by three stops (Zone II).
- ~ Leave the adjacent frame unexposed.
- ~ Process the negatives according to the manufacturer's specifications.
- ~ Place half of each frame (unexposed and Zone II ) in a negative carrier.

- ~ Make a step test using a normal contrast filter or grade two paper.
- ~ Establish the minimum time to achieve maximum black (MTMB).
- ~ The tone alongside the MTMB Should appear as Zone II (nearly black).

MTMB 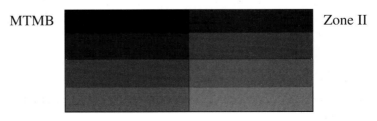 Zone II

If the adjacent tone to the MTMB exposure on the test strip is too light (dark grey), decrease the processing time. If the adjacent tone to the MTMB exposure on the test strip is too dark (black), increase the processing time.

# Processing

Processing is calibrated by checking the accuracy of the highlight tones on the negative. This can be achieved by using a **'densitometer'** or by conducting the following clip test.

~ Overexpose a grey card by three stops (Zone VIII).
~ Leave the adjacent frame unexposed.
~ Process the negatives according to the manufacturers specifications.
~ Place half of each frame (unexposed and Zone VIII ) in a negative carrier.

~ Make a step test using a normal contrast filter or grade two paper.
~ Establish the minimum time to achieve maximum black (MTMB).
~ The tone alongside the MTMB Should appear as Zone VIII (light tone).

MTMB 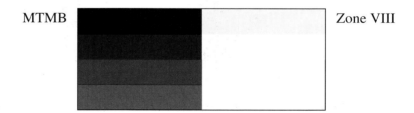 Zone VIII

If the adjacent tone to the MTMB exposure on the test strip is too light (paper white), decrease the processing time.  If the adjacent tone to the MTMB exposure on the test strip is too dark (Zone VII), increase the processing time.

# Activity 4

Choose a 100 and 400 ISO film and conduct the exposure and processing tests as outlined on these pages.
Discuss your findings with other students.

# Perfecting the system

For accurate previsualisation the photographer must be familiar with **all** the materials and equipment in the chain of image creation. A common mistake is choosing a few very dark shadows to place in Zone III and the brightest highlights to place in Zone VII. The result may be a flat low contrast image with the majority of the image placed in only three zones. Each time the system is operated the individual's ability to accurately previsualise the outcome improves.

## Summary

- Take a reflected meter reading of a shadow tone.

- Place in Zone III by closing down two stops.

- Take a reflected meter reading of a highlight tone.

- Calculate how many stops brighter the highlight is than the shadow.

- Calculate the processing time using the information below.

---

**Average processing adjustments for 100 ISO film**

| Contrast | | Processing time % |
|---|---|---|
| Highlight 6 stops brighter than Zone III | N+2 | 150 |
| Highlight 5 stops brighter than Zone III | N+1 | 130 |
| Highlight 3 stops brighter than Zone III | N−1 | 85 |
| Highlight 2 stops brighter than Zone III | N−2 | 75 |

---

# Activity 5

Revisit the location you photographed in Activity 1 at the same time of day with the same lighting (directional sunlight required).
Using the zone system create an image with a full tonal range. Choose the shadow and highlight details you wish to place in Zone III and Zone VIII.
Expose, process and print the negative to obtain the final image.
Compare the results achieved in this assignment with the image created for Activity 1 and discuss the visual qualities with other students.

# Revision exercise

Q1.  How many zones are there in the zone system?

Q2.  Describe what the term **'previsualisation'** means?

Q3.  List the benefits and the limitations of using the zone system.

Q4.  What relevance does the **'18% grey card'** have to the zone system?

Q5.  What is **'zone placement'**?

Q6.  How many stops difference are there in between Zone III and Zone VIII?

Q7.  If shadow detail is missing on the normally processed negative (clear film base), would increasing the processing time restore the shadow detail?

Q8.  Describe the appearance of a typical Zone III and Zone VIII in a final print.

Q9.  How do you establish an exposure index of a black and white film?

Q10.  Does increasing the processing time of a film increase or decrease the contrast?

Q11.  If the metered shadow reads f4 @ 1/125 second and the metered highlight reads f22 @ 1/125 second how would you expose and process the film to achieve a full tonal range print?

# Resources

*Beyond the Zone System - Phil Davis.* Focal Press. London. 1998.
*Photography - London and Upton.* Harper Collins College Publishers. New York. 1994.
*The Negative - Ansel Adams.* Little, Brown. Boston. 1988.
*The Practical Zone System - Chris Johnson.* Focal Press. 1994.
*The Zone System for 35mm Photographers - Carson Graves.* Focal Press. London. 1997.
*The Zone System manual - Minor White.* Hastings-on-Hudson. New York. 1968.

# Gallery

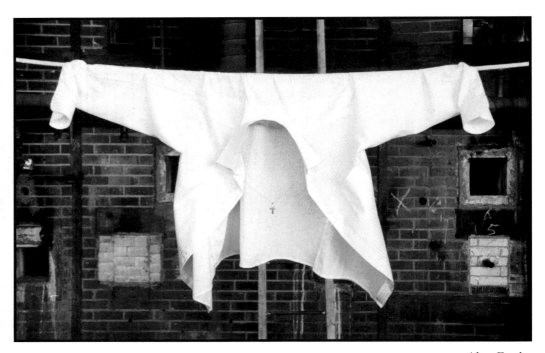

*Alan Fredes*

*Kate Tan*

# Landscape

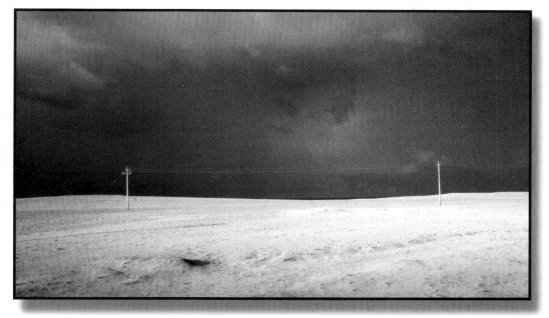

*The Apostles - Mark Galer*

## Aims

~ To increase knowledge of the historical development of the landscape image.
~ To express ideas, convictions or emotions through landscape images.
~ To develop an understanding of how different techniques can be employed to aid personal expression.

## Objectives

~ **Research** - Produce research in your visual diary that looks at a broad range of landscape images.
~ **Discussion** - Exchange ideas and opinions with other students about the work you are engaged in.
~ **Practical work** - Produce photographic images exploring expressive landscape photography in response to the activity and assignment briefs in this chapter.

# Introduction

Picture postcards, calendars and travel brochures show us glimpses of romantic, majestic and idyllic locations to be admired and appreciated.  The beautiful and wonderful is identified, observed, recorded and labelled repeatedly by professionals, tourists and travellers.  Mankind is responding to the basic social needs and expectations to capture, document and appreciate.  I came, I saw, I photographed.  Photography allows the individual to pay homage to beauty and achievement as if in some religious ritual.  We mark the occasion of our endeavour and our emotional response by taking a photograph.

> "Most tourists feel compelled to put the camera between themselves and whatever is remarkable that they encounter.  Unsure of other responses they take a picture.  This gives shape to experience: stop, take a photograph, and move on".  Susan Sontag - On Photography.

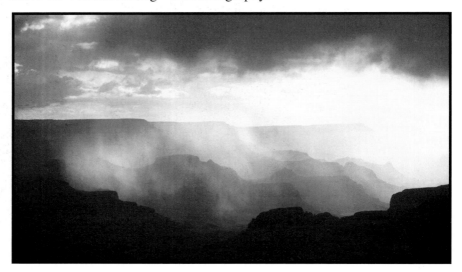

*Canyon and rain*

Professional photographers set the benchmarks of aesthetic representation and illustration to which the amateurs strive to replicate.  What can sometimes be missing from these images is the photographer's emotional and physical connection to this environment.  There may be no obvious personal response or signature visible in the image.  It's almost as if nature has drawn herself with minimal interference from the human consciousness responsible for the images production.  The result may be a loss of the sense of the location as seen by the individual.

To connect with the environment and communicate the emotional responses from this connection is a difficult task.  It requires considerable skill from both the photographer and viewer to establish meaning other than stereotypical representation.  To understand and appreciate the complexity of the genre we must first understand the historical context in which we read the imagery produced.

# History

Many of the early photographers entered the medium from a scientific rather than an art background.  The images produced served as factual records or looked to the art world for guidance in such things as composition and choice of content.  Fox Talbot described his early photographs as being created by the 'pencil of nature'.  On the one hand the medium was highly valued because of the great respect for nature at this time.  On the other hand the medium was rejected as art because many perceived this as a purely objective and mechanical medium.  Is photography art?  Photographers needn't look to the art establishment to answer this question but simply apply their own unique subjectivity to their work and explore the possibilities of the medium.

*The Open Door, Lackock Abbey - Henry Fox Talbot*

# Europe

The practice of recording the environment as the principal subject matter for an image is a fairly modern concept.  Prior to the 'Romantic Era' in the late 18th century, the landscape was merely painted as a setting or backdrop for the principal subject.  Eventually the environment and in particular the natural environment began to be idealized and romanticised. The picturesque aesthetic of beauty, unity and social harmony was established by painters such as John Constable and William Turner working just prior to the invention of photography.  Many of the first landscape photographs were not however inspired by aesthetics but by the demand for 'Foreign scenics' (views of the exotic places of the world).  One of the early travelling photographers supplying images for the public appetite for these images was Francis Frith.  Frith however believed that the images he produced should also be considered as art.  He published a paper in 'The Art Journal' in 1859 entitled "The Art of Photography".  This photographic art became known as **'Pictorial photography'.**

# Pictorial photography

Pictorial photography emerged shortly after the birth of photography itself. Pictorial photographers believed that the camera could do more than simply document or record objectively. The pictorial approach was not so much about information as about effect, mood and technique. Dr. Peter Henry Emerson promoted photographic 'Naturalism' in 1889 in his book 'Naturalistic Photography for Students of Art'. Emerson believed that photographers shouldn't emulate the themes and techniques of the painters but treat photography as an independent art form. He encouraged photographers to look directly at nature for their guidance rather than painting. He believed that photography should be both true to nature and human vision. He promoted the new theories of human vision which stated that we see in sharp focus only around the central area of our gaze, vision steadily blurring towards the periphery. Emerson promoted the concept that each photographer could strive to communicate something personal through their work.

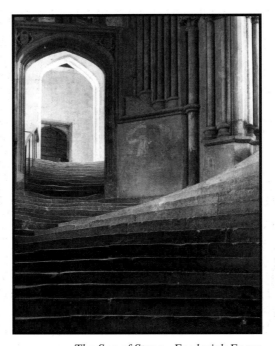

*The Sea of Steps - Frederick Evans*

# Straight photography

Although many photographers were inspired by Emerson's work (especially in the choice of natural or existing subject matter) the vast majority tried to make their photographs look as much like drawings or paintings as possible by manipulation of the medium.
Frederick Evans was an exception believing in a non-manipulative approach called 'Straight photography'. This is visible in such photographs as 'Sea of Steps' which he produced in 1903. He believed the emphasis should lie in the 'seeing' and not the later manipulation in order to communicate the artists feelings.

# America

Photography arrived at a time when the exploration of new lands was being undertaken by western culture.  Photography was seen as an excellent medium by survey teams to categorise, order and document the grandeur of the natural environment in western America.  Typical examples can be seen in the work of William Henry Jackson.  These landscapes showed no evidence of settlement by mankind.  A sense of the vast scale was often established by the inclusion of small human figures looking in awe at the majestic view.  The images communicated humankind in awe of God.  These majestic views and their treatment by American photographers contrasted greatly with European landscape photographs.  Landscape painters and photographers in Europe did not seek isolation.  Indeed seeking out a sense of isolation is problematic in an industrialized and densely populated land.  There is usually a hint, or more than a hint, of human presence - a fence, a dirt track, archaeological remains, etc.

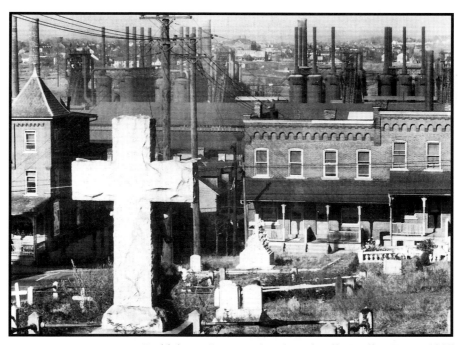

*Bethlehem, Graveyard and steel mill - Walker Evans 1935*

# A documentary approach

In the 20th century, photographers continued to document the American landscape.  Roy Stryker of the Farm Security Administration (FSA) commissioned many photographers in the 1930s to document life in America during the depression.  Arthur Rothstein, Dorothea Lange and Walker Evans produced a strong body of landscape work which helped to place Americans in context with their environment.

## Photo-secessionists

The other major influence on American photography came from Europe. Alfred Stieglitz returned home to New York from Germany bringing with him the European influences of Naturalistic photography and modern pictorialism. In 1902 he exhibited under the title 'Photo-Secessionists' with nonconformist pictorial photographs, choosing everyday subject matter taken with a hand-held camera. The quarterly magazine 'Camera Work' and a secessionist gallery helped promote Stieglitz's vision for photography to become accepted as an aesthetic medium.

*Dunes, Oceano, California 1963 - Ansel Adams*

## F64

The last issue of Camera Work in 1917 featured the work of Paul Strand who had been taught photography by Lewis Hine whilst at school. Strand pioneered 'straight photography' fully exploring the medium's strengths and careful observation of subject matter. The work and ideas influenced photographers such as Edward Weston and Ansel Adams who decided to take up this new 'Realism'. They formed the group F64 and as the name suggests produced images using the smallest possible apertures on large format cameras for maximum sharpness and detail throughout the image area.

Straight photography heralded the final break from the pursuit of painterly qualities by photographers. Sharp imagery was now seen as a major strength rather than a weakness of the medium. Photographers were soon to realise this use of sharp focus did not inhibit the ability of the medium to express emotion and feeling.

# Personal expression

The image can act as more than a simple record of a particular landscape at a particular moment in time.  The landscape can be used as a vehicle or as a metaphor for something personal the photographer wishes to communicate.  The American photographer Alfred Stieglitz called a series of photographs he produced of cloud formations "equivalents", each image representing an equivalent emotion, idea or concept.  The British landscape photographer John Blakemore is quoted as saying:

> "The camera produces an intense delineation of an external reality, but the camera also transforms what it 'sees'.  I seek to make images which function both as fact and as metaphor, reflecting both the external world and my inner response to, and connection with it".

*Rocks and Tide, Wales - John Blakemore*

> "Since 1974, with the stream and seascapes, I had been seeking ways of extending the photographic moment.  Through multiple exposures the making of a photograph becomes itself a process, a mapping of time produced by the energy of light, an equivalent to the process of the landscape itself".

John Blakemore, 1991

Communication of personal ideas through considered use of design, technique, light and symbolic reference is now a major goal of many landscape photographers working without the constrains of a commercial brief.  Much of the art world now recognises the capacity of the photographic medium to hold an emotional charge and convey self expression.

# Alternative realities

There is now a broad spectrum of aesthetics, concepts and ideologies currently being expressed by photographers. The camera is far from a purely objective recording medium. It is capable of recording a photographer's personal vision and can be turned on the familiar and exotic, the real and surreal. This discriminating and questioning eye is frequently turned towards the urban and suburban landscapes the majority of us now live in. It is used to question the traditional portrayal of the rural landscape (romantic and idyllic) as a mythical cliche. It explores the depiction of the natural landscape for many urban dwellers as a mysterious location, viewed primarily through the windscreen of the car and from carefully selected vantage points. Photographers such as Martin Parr now present different views of familiar locations and offer alternative realities. Landscape is used frequently as a political tool, reflecting the values of society. The landscape traditionally portrayed as being unified and harmonious may now be portrayed as confused and cluttered and in turn express the conflict, between expectation and reality.

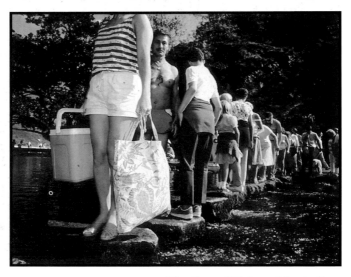

*The Cost of Living - Martin Parr*

Photographers also explore their personal relationship with their environment using the camera as a tool of discovery and revelation. To make a photograph is to interact and respond to the external stimuli that surround us. We may respond by creating images that conform to current values and expectations or we may create images that question these values. To question the type of response we make and the type of image we produce defines who we are and what we believe in.

# Activity 1

Find two landscape photographs that question social values or act as a metaphor for personal issues that the photographer is trying to express. Discuss whether the communication is clear or ambiguous and how this communication is conveyed.

# Expressive techniques

Sweeping panoramas are not caught by the frame of a standard lens. When a wide angle lens is attached to include more of the panorama the resulting images may be filled with large areas of empty sky and foreground. This does little for the composition and can make the subject of interest seem far away and insignificant. The lens does not discriminate, recording everything within its field of vision. Painters recording a landscape have the option of eliminating information that would clutter the canvas or detract from the main subject matter. Unlike the painter, a photographer can only remove superfluous detail by using a carefully chosen vantage point or by moving in closer to reduce the information that is contained within the frame. If the photographer moves in too close, the feeling of the broader landscape is lost.

*Mt. Bulla*

Although it is difficult to communicate personal ideas or feelings and capture the mood of a location it is nevertheless possible and, when achieved, can be one of the most rewarding photographic experiences. Through increased awareness, careful observation and knowledge of the elements that create a successful landscape photograph the photographer can learn to achieve expressive and effective results consistently.

## Activity 2

Compare and contrast two landscape photographs with two landscape paintings.
Discuss the expressive possibilities of each medium using your examples to illustrate your argument.
Choose your examples carefully as representative of the medium.

# Light

As previously stated in the chapter on light the use of low light is essential to increase the range of moods. The changes in contrast, hue and colour saturation found in low light conditions can all be used to extend the expressive possibilities for the photographer.

## Extreme brightness range

With an extreme brightness range the exposure between land and sky is often a compromise. Sky may become overexposed when detail is required in the land, land may become underexposed when detail is required in the sky. The brightness range can be controlled by filtration, careful exposure, processing and printing when using black and white film.

*Annapurna*

## Polarising filters

Polarising filters provide increased colour saturation and deeper blue skies. The filter should be removed when the effect is not required. If not removed the photographer will lose two stops and reduce the ability to achieve overall focus. When used in conjunction with a wide angle lens the photographer should remove any filter already in place. This will eliminate the problem of tunnel vision or clipped corners. Unnatural gradation may also occur ranging from a deep blue polarised sky on one side of the frame to a lighter blue non-polarised sky on the other.

Another option to balance the exposure when using colour film is by the use of a gradation or gradual filter. This filter reduces the exposure to the sky and leaves the land unaffected. These filters have to be used with great care to avoid an unnatural effect.

## Filters for black and white

When the landscape photographer is using black and white film there is the option of controlling tonal rendition and contrast by using coloured filters. The basic rule when using coloured filters with black and white film is:

**Adjacent colours are lightened – Opposite colours are darkened**

Filter factors are indications of the increased exposure necessary to compensate for the density of the filter. A filter factor of two equals one stop, four equals two stops and eight equals three stops.

| Name | Colour | Filter Factor | Effect |
|------|--------|---------------|--------|
| PL | Grey | 2.5 - 3 | Reduces or eliminates reflections, |
| Y2 | Yellow | 2 | Lowers exposure of blue sky. |
| G | Green | 4 | As for Y2 plus lightens green foliage and renders good skin tones for daylight portraits |
| YG | Yellow/Green | 2 | Corrects tones to that of human vision. |
| O2 | Orange | 4 | Blue skies record as middle tones. |
| R2 | Red | 8 | Creates dark and dramatic skies. Underexposes green foliage. |

## Process to control contrast

Decreasing the processing time will lower the contrast of a black and white negative. For further information see "**The Zone System**" in this book or any manual which refers to the practical application of the 'zone system' as developed by Ansel Adams.

**Expose for the shadows and process for the highlights**

# Composition

Composing subject matter is more than an aesthetic consideration. It controls the way we read an image and the effectiveness of the photographer's communication. The chapter "Framing the Subject" at the beginning of this book deals with many aspects of communication that can be applied to the creation of landscape photographs. The photographer should consider the following which are particularly relevant:

~   **format and horizon line**
~   **depth**
~   **scale**

# Format and horizon line

The most powerful design elements that the landscape photographer has to work with are choice of format and positioning of the horizon line. Most landscape images produced are horizontal or landscape format images. The use of the landscape format emulates the way we typically view the landscape . To further emulate the human vision many photographers make use of panoramic cameras or crop to a wider image to reduce the viewer's sensation of viewing a truncated image.

Many photographers make the mistake of over using the vertical or portrait format when faced with tall buildings or trees, etc. Students should explore both formats when faced with a similar location and compare the communication of each.

The placement of the horizon line within the frame is critical to the final design. A central horizon line dividing the frame into two halves is usually best avoided. The photographer should consider whether the sky or foreground is the more interesting element and construct a composition according to visual weight and balance.

*Lake Toba*

# Open or closed landscape

By removing the horizon line from the image (through vantage point or camera angle) the photographer creates a closed landscape. In a closed landscape a sense of depth or scale may be difficult for the viewer to establish.

# Activity 3

Create two photographs in a location with tall buildings or trees using both formats.
Compare and discuss the visual effect of each image.
Create a closed and open landscape at one location.
Discuss the different ways we read the resulting images.

# Depth

Including foreground subject matter introduces the illusion of depth through perspective and the image starts to work on different planes. Where the photographer is able to exploit lines found in the foreground the viewer's eye can be lead into the picture. Rivers, roads, walls and fences are often used for this purpose.

By lowering the vantage point or angling the camera down, the foreground seems to meet the camera. A sense of the photographer in, or experiencing the landscape can be established. In the photograph below the beach and cliff walls are included along with the author's own footsteps to establish a sense of place.

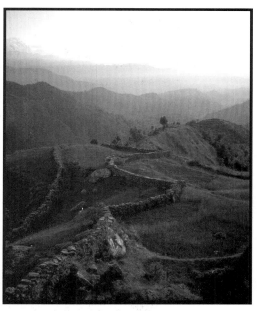

*Machapuchari*

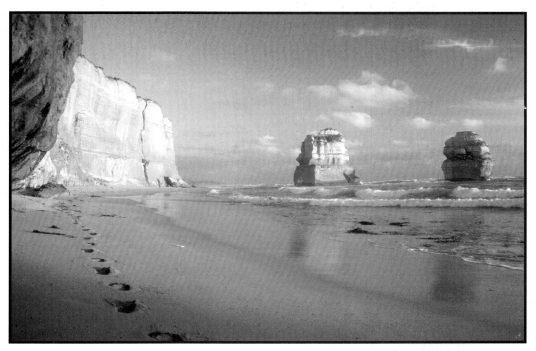

*Gibson's Steps*

# Activity 4

Create two landscapes utilising foreground subject matter to create a sense of depth. Discuss how the resulting images are likely to be read by the viewer.

# Scale

Where the photographer is unable to exploit foreground interest it is common to include subject matter of known size. This gives the viewer a sense of scale which can often be lost in images that seemingly exist on only one plane. The lone figure on the summit of an active volcano in the photograph below adds not only a focal point of interest but also scale.

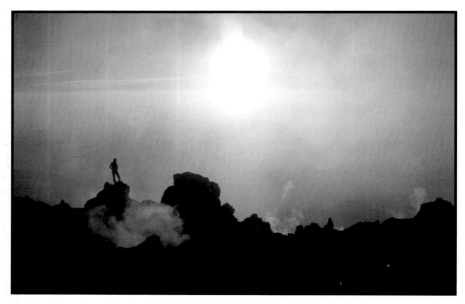

*Merapi*

# Focal length

A wide angle lens is a favourite tool of the landscape photographer. It has the potential to create images with exaggerated perspective and greater depth of field. Foreground detail is vital to prevent empty images.

The telephoto lens is often overlooked when photographing landscape images. The photographer Andreas Feininger made a series of dramatic images of New York using very long telephoto lenses. Feininger did not like the distortion of scale when using wide angle lenses close to the subject matter. He preferred to photograph the correct relationship of scale by shooting at a distance with a longer lens.

Where a high vantage point has been found the compression of detail and subject matter can be used to create dramatic designs. Photographers working at a distance with long lenses should take precautions against overexposure due to excessive UV light. Slight underexposure and use of UV or Skylight filters is strongly recommended.

# Activity 5

Find two landscape images taken with a wide angle lens and two using a telephoto lens. Discuss the communication and design differences between each.

# Detail

The photographer can communicate more about the natural environment than just with images of the broad landscape.  With more than one image possible on a roll of film the photographer is not restricted to making a single carefully chosen statement about a natural landscape on a particular day.  With keen visual awareness and close observation the photographer is able to move in close, isolate particular features, and build a more detailed impression of a location.  By moving in close, depth of field is reduced, so aiding the photographer's attempt to isolate single features within a complex environment.

*Erosion*

## Macro

Very small features may be photographed with the aid of a macro lens or a relatively inexpensive close-up lens.  The close-up lens is screwed onto the front of an existing lens like a filter and is available in a range of dioptres.  The photographer using macro capabilities to capture nature should be aware of the very shallow depth of field when shooting at wide apertures.  Photographers using the smaller apertures can incur a number of problems.  Extended shutter speeds may require the use of a tripod or monopod and any wind may cause the subject to blur.

Monopods are preferred by many who find the speed advantage over a tripod invaluable. An insect visiting a flower is often gone by the time the legs of a tripod are positioned. Many photographers specialising in this area of photography often resort to using wind breaks to ensure that the subject remains perfectly still during an extended exposure. These wind breaks can be constructed out of clear polythene attached to three or four wooden stakes so that a natural background can be retained.  One or more of the sides can be a white translucent material that can act as a reflector or a diffuser to lower the contrast of harsh direct sunlight.

# Night photography

One of the best times to take night photographs is not in the middle of the night but at dusk, before the sky has lost all of its light. The remaining light at this time of day helps to delineate the buildings and trees from the night sky.

Night photography is often seen as a technically demanding exercise. With a little extra equipment and a little knowledge however the pitfalls can easily be avoided. Use a tripod to brace the camera, a cable release to release the shutter (optional if using the self timer) and a torch to set controls of the camera. Pushing film should be avoided as this increases the contrast of an already high contrast subject. A medium speed film used in conjunction with a tripod usually gives the best results.

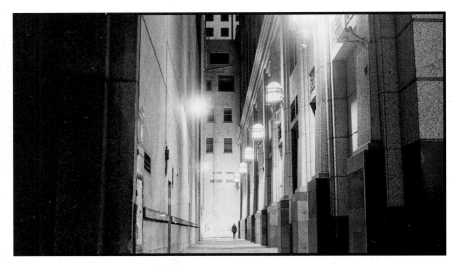

*Travis Clifford*

## Using a TTL meter to calculate night exposures

Set the camera to manual exposure mode. Frame part of the scene where the artificial lights will not overly influence the meter (avoid lights directed towards the camera and/or in the centre of the frame). If the reading is off the meter's scale try opening the aperture or changing the ISO of the film in order to establish a reading. Reset the ISO or aperture and then calculate the additional exposure needed. For exposures of 1 to 5 seconds open the aperture by one stop to allow for **'reciprocity failure'**. For exposures over 10 seconds open the aperture one stop for colour negative, one-and-a-half stops for colour transparency and two stops for black and white negative. Bracket several exposures to ensure the best exposure using the aperture rather than the shutter speed.

## Activity 6

Record the same location during twilight and at night, bracketing the exposures for each. Discuss the visual changes in the lighting quality of each set of images.

# The constructed environment

When Arthur Rothstein, FSA photographer, moved a skull a few metres for effect he, and the FSA, were accused of fabricating evidence and being dishonest.  A photograph however is not reality.  It is only one person's interpretation of reality.  Rothstein perceived the skull and the broken earth at the same time and so he included them in the same physical space and photograph to express his emotional response to what he was seeing.  Is this dishonest?

The photograph can act as both a document and as a medium for self expression.  Truth lies in the intention of the photographer to communicate visual facts or emotional feelings.  Sometimes it is difficult for a photograph to do both at the same time.

*Dreams will come true - Matthew Orchard*

The majority of photographers are content with responding to and recording the landscape as they find it.  A few photographers however like to interact with the landscape in a more concrete and active way.  Artists such as Andy Goldsworthy use photography to record these ephemeral interactions.  Goldsworthy moves into a location without preconceived ideas and uses only the natural elements within the location to construct or rearrange them into a shape or structure that he finds meaningful.  The day after the work has been completed the photographs are often all that remain of Goldsworthy's work.  The photograph becomes both the record of art and a piece of art in its own right.

## Activity 7

Make a construction or arrangement using found objects within a carefully selected public location.  Create six images showing this structure or arrangement in context with its surroundings.  Consider framing, camera technique and lighting in your approach.

# Assignments

Produce six images that express your emotions and feelings towards a given landscape . Each of the six images must be part of a single theme or concept and should be viewed as a whole rather than individually.

People may be included to represent humankind and their interaction with the landscape. The people may become the focal point of the image, but this is not a character study or environmental portrait where the location becomes merely the backdrop.

1. Wilderness.
2. Seascape.
3. Suburbia.
4. Sandscape.
5. Inclement weather.
6. The city or city at night.
7. Mountain.
8. Industry.
9. Arable land.

The requirements for the above assignment must be clarified with your tutor prior to undertaking any work. Tick the requirements below.

**Medium** (film)

| Black & white | | Colour negative | | Transparency | |
|---|---|---|---|---|---|

**Format** (camera)

| 35mm | | Medium format | | Large format | |
|---|---|---|---|---|---|

**Presentation requirements** ........................................................................................
(size of prints/slide presentation, etc.)

# Resources

*A Collaboration with Nature - Andy Goldsworthy.* Abrams. New York. 1990.
*On Photography - Susan Sontag.* Farrar, Strauss and Giroux. New York. 1989.
*Inscape - John Blakemore.* Zelda Cheatle Press. London. 1991.
*In This Proud Land - Stryker and Wood.* New York Graphic Society. New York. 1973.
*Land - Faye Godwin.* Heinemann. London. 1985.
*Naturalistic Photography for Students of the Art - P. H. Emerson.* Arno Press. NY. 1973.
*The History of Photography: an overview - Alma Davenport.* Focal Press. 1991.
*The Photograph - Graham Clarke.* Oxford University Press. New York. 1997.
*The Portfolios of Ansel Adams.* New York Graphic Society. Boston. 1977.
*The Story of Photography - Michael Langford.* Focal Press. Oxford. 1992.

# Gallery

*Alison Ward*

*Lucas Dawson*

# Gallery

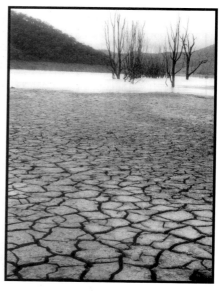

*Kalimna Brock*

*Lucas Dawson*

*Alexandra Yourn*

# Gallery

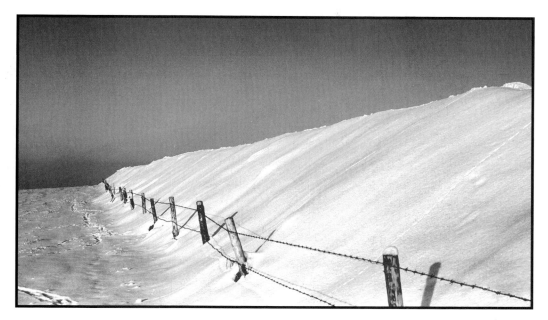

*Mark Galer*

*Michael Wennrich*

# Gallery

*Mark Galer*

*Simon Sandlant*

# Environmental Portraits

*Mark Galer*

## Aims

~ To develop an increased awareness of the actions and interactions of a broad spectrum of people.
~ To develop personal skills in directing people.
~ To develop essential technical skills to work confidently and fluently.

## Objectives

~ **Research** - Photographers noted for their skills in photographing people (portraiture and documentary).
~ **Discussion** - Exchange ideas and opinions with other students.
~ **Practical work** - Produce images through close observation and selection that demonstrate:
  - a comfortable working relationship with people at close range.
  - appropriate design and technique.

# Introduction

The craft of representing a person in a single still image or 'portrait' is to be considered a skilled and complex task. The photographic portrait (just as the painted portrait that influenced the genre) is not a candid or captured moment of the active person but a crafted image to reveal character.

The person being photographed for a portrait should be made aware of the camera's presence even if they are not necessarily looking at the camera when the photograph is made. This requires that the photographer connect and communicate with any individual if the resulting images are to be considered portraits. Portraits therefore should be seen as a collaborative effort on the part of the photographer and subject. A good photographic portrait is one where the subject no longer appears a stranger.

*Julian - David Lew*

The physical surroundings and conditions encountered on location whilst making a portrait image offer enormous potential to extend or enhance the communication. Just as facial expression, body posture and dress are important factors, the environment plays a major role in revealing the identity of the individual. The environmental portrait for this reason has become a genre in its own right.

Environmental portraits are produced commercially for a number of reasons. The environmental portrait may be produced to stand alone to illustrate an article about a person that is of public interest. It may also be the central or key image of a collection of images that together form a photo-essay or social documentary.

# Activity 1

Look through assorted books, magazines and newspapers and collect four images where the environment plays an important role in determining an aspect of the subject's character or identity.

Discuss how the subject relates to the environment in each image.

# Portrait mode

Sophisticated 35mm SLR cameras often provide a 'Portrait Mode'. When this programme mode is selected a combination of shutter speed and aperture is selected to give the correct exposure and a visual effect deemed suitable for portrait photography by the camera manufacturers. The visual effect aimed for is one where the background is rendered out of focus, i.e. shallow depth of field. This effect allows the subject to stand out from the background, reducing background information to a blur. Although this effect may be pleasing for some portrait images it is not suitable for most environmental portraits where more information is required about the physical surroundings and environment. The photographer intending to shoot environmental portraits is recommended to use aperture priority or manual in most situations so that maximum control is maintained.

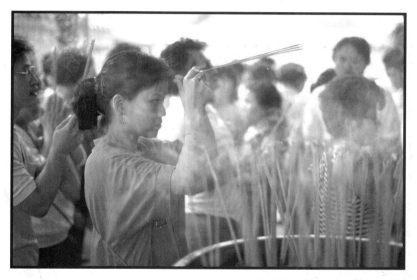

*Buddhist Temple, Singapore*

# Portrait lenses

Photographic lenses can be purchased by manufacturers which are often referred to as 'portrait lenses'. The 'ideal' portrait lens is considered by the manufacturers to be a medium telephoto lens such as a 135mm lens for a 35mm camera. This lens provides a visual perspective that does not distort the human face when recording head and shoulder portraits. The problem of distortion however is not encountered with shorter focal length lenses if the photographer is not working quite so close to the subject. To record environmental portraits with a telephoto lens would require the photographer to move further away from the subject and possibly lose the connection with the subject that is required. Standard and wide angle lenses are suitable for environmental portraiture.

# Activity 2

Photograph the same subject varying both the depth of field and focal length of lens. Discuss the visual effects of each image.

# Framing the subject

In order for the photographer to reveal the connection between the subject and the environment the photographer must carefully position or frame the two elements together. Vantage point, cropping and choice of scale become critical factors in the design. The relationship and connection between foreground and background becomes a major design consideration for an environmental portrait.

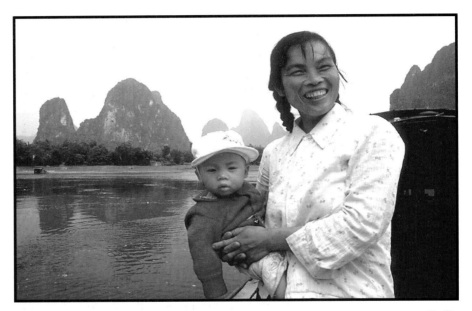

*Guilin*

## Choice of format

The choice of vertical or horizontal framing and the placement of the subject within the frame will effect the quantity of environmental information that can be viewed in the resulting image. A centrally placed subject close to the camera will marginalize the environmental information. This framing technique is more difficult to utilise but should not be ruled out for creating successful environmental portraits. Using the portrait format for environmental portraits usually requires the photographer to move further back from the subject so that background information is revealed.

## Activity 3

Find four environmental portraits that demonstrate the different ways a photographer has framed the image to alter meaning or content. Discuss the photographer's vantage point, use of scale, depth of field and subject placement in all of the images.

# Choice of environment

Significant and informative details can be included within the frame with the subject. These details may naturally occur in the chosen environment or be introduced for the specific purpose of strengthening the communication. Connections may be made through the 'tools of the trade' associated with the individual's occupation. Informative artefacts such as works of art or literature may be chosen to reflect the individual's character. Environments and the lighting may be chosen to reflect the mood or state of mind of the subject.

*Indian Sahdu*

The objects or subject matter chosen may have symbolic rather than direct connection to the subject. In the above image the twisted forms of the tree echo the distorted body of the Indian Sahdu or holy man.

# Activity 4

Compose one image considering carefully the inclusion or juxtaposition of significant or informative detail.

Describe the importance of the additional information and how it is likely to be read by the viewer.

# Composing two or more people

Composing two or more people within the frame for an environmental portrait can take considerable skill. People will now relate with each other as well as with the environment. The physical space between people can become very significant in the way we read the image. For a close-up portrait of two people the space between them can become an uncomfortable design element. Careful choice of vantage point or placement of the subjects is often required to achieve a tight composition making optimum use of the space within the frame.

*Trans-Siberian railway*

The situation most often encountered is where two people sit or stand side by side, shoulder to shoulder. If approached face on (from the front) the space between the two people can seem great. This can be overcome by shooting off to one side or staggering the individuals from the camera. The considerations for design are changed with additional subjects.

# Activity 5

Collect four environmental portrait images with two to five subjects.
In at least one image the subject should have been placed in the foreground.
Comment on the arrangement of the subjects in relation to the camera and the effectiveness of the design.

# Photographing strangers

The shift from receptive observer to active participant can sometimes be awkward and difficult for both the potential subject and the photographer. These feelings of awkwardness, embarrassment or even hostility may arise out of the subject's confusion or misinterpretation over the intent or motive behind the photographer's actions. The photographer's awkwardness or reticence to connect often comes from the fear of rejection.

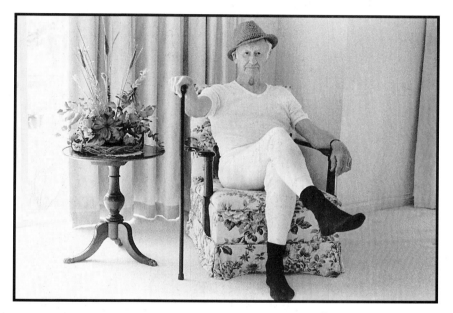

*Superman - Kate Mills*

## Making a connection

The initial connection with the subject is crucial for a successful environmental portrait. If the photographer is taking images at an event or activity the photographer must be very aware when someone within the frame makes eye contact with the camera. At this decisive moment the posture and facial expression usually remains unchanged from where the subject's attention was previously engaged. The photographer should be able to capture a single frame at this moment before lowering the camera. There is no time for re-focusing, re-framing and adjusting exposure. The camera should be lowered and a friendly and open response offered by the photographer. If the photographer continues to observe the subject after having been noticed the subject's sense of privacy can be invaded and the photographer's chance for an amicable contact can be lost. Most people will gladly co-operate if a friendly connection has first been established.

# Contact

The first verbal connection with the subject should be considered carefully. Asking people for their permission to be photographed requires a considered response on the subject's behalf ("What are they selling" and "who will see the picture?" etc.). Unsure of the implications of consenting to be photographed many people will refuse their permission. Once refused it is not always possible to persuade someone that their acceptance to be photographed would have no further implications, i.e. they would not be required to purchase the photograph, give consent for publication, etc. The first verbal connection should simply be who you are.

Many photographers will arrange a preliminary visit to a location if there is time available. This will afford individuals present at the location to get used to the photographer's presence and feel comfortable being photographed. This is especially useful at small or enclosed events, as it may be difficult for the photographer to work unnoticed. If introductions haven't first been made the photographer may cause some disruption at the event or activity. Successful environmental portraits are often dependent on the initial interactions the photographer has with the potential subject.

# Interaction

Putting a subject at ease in front of the camera is dependent on two main factors.

    **1.  The subject is clear about the photographers <u>motive</u>s.**

    **2.  The subject sees <u>value</u> in the photographs being made.**

**Motive** - many people view an unknown photographer with curiosity or suspicion. Who is the photographer and why are they taking photographs? It is essential that the photographer learns to have empathy with the people he/she intends to photograph. A brief explanation is therefore necessary to help people understand that the photographer's intentions are harmless.

**Value** - many people see the activity or job that they are doing as uninteresting or mundane. They may view their physical appearance as none photogenic. The photographer needs to explain to the subject what it is that he/she finds interesting or of value and why. If the activity the subject has been engaged in appears difficult or demanding and requires skill, patience or physical effort, the photographer should put this view forward. The photographer should continue to ask questions whilst photographing so that the subject is reassured that the interest is genuine.

# Direction

The photographer should display an air of confidence and friendliness whilst directing subjects. Subjects will feel more comfortable if the photographer clearly indicates what is expected of them. There can be a tendency for inexperienced photographers to rush an environmental portrait. The photographer may feel embarrassed, or feel that the subject is being inconvenienced by being asked to pose. The photographer should clarify that the subject does have time for the photograph to be made and indicate that it may involve more than one image being created. A subject may hear the camera shutter and presume that one image is all that is required.

## Passive subject

Subjects should be directed to pause from the activity that they were engaged in. The photographer can remain receptive to the potential photographic opportunities by keeping the conversation focused on the subject and not oneself.

## Expression and posture

Often a subject will need reminding that a smile may not be necessary. Subjects may need guidance on how to sit or stand, what they should do with their hands and where to look. It may be a simple case of just reminding them how they were standing or sitting when you first observed them.

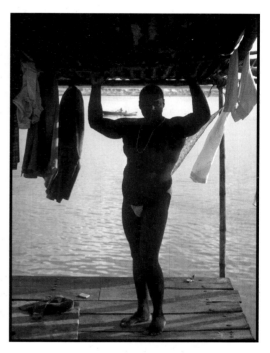

*Brahmin, India*

## Shooting decisively

As a photographer takes longer to take the picture the subject will often feel more and more uncomfortable about their expression and posture. To freeze human expression is essentially an unnatural act. Exposure, framing and focus should all be considered before raising the camera to the eye.

# Activity 6

Connect with four strangers and take three environmental portraits of each.
At least one image of each person should demonstrate how you have directed them towards a relaxed expression and body posture.
Discuss the process of direction for each.

# Character study

Environmental portraits often stand alone in editorial work but can also form part of a larger body of work. A series of environmental portraits may be taken around a single character, or characters, connected by profession, common interest or theme.

With additional images the photographer is able to vary the content and the style in which the subject is photographed to define their character within the study. The photographer may choose to include detail shots such as hands or clothing to increase the quality of information to the viewer. The study may also include images which focus more on the individual (such as a straight head and shoulders portrait) or the environment to establish a sense of place.

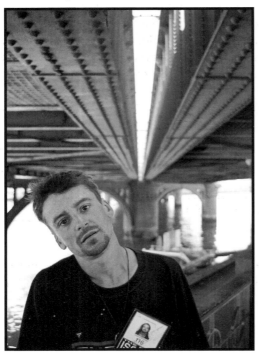

*The Big Issue - Sean Killen*

The images above show the diversity of approach to present the character of a single individual. The images are of Martin, a homeless individual who lived under a bridge in Melbourne and who sold copies of 'The Big Issue' to support himself.

# Activity 7

Collect one photographic essay where the photographer has varied the content of the images to define the character or characters of the individual or individuals.

Describe the effectiveness of the additional images that are not environmental portraits.

# Assignment

Produce six environmental portraits giving careful consideration to design, technique and communication of character. At least one of the images should include more than one person. Choose one category from the list below.

1. Manual Labourers ................... dockers, builders, mechanics, bakers, etc.
2. Professional People.................................... doctors, nurses, lawyers, etc.
3. Craftsmanship......... ...................... potters, woodworkers, violin makers, etc.
4. Club or team members ............................ cricketers, golfers, scouts, etc.
5. Corporate image................................ business consultants, bankers, etc.
   *This study should include three environmental portraits,*
   *two images of close-up detail and one portrait.*
6. Character study ...................................... celebrity, politician, busker, etc.
   *This study should include three environmental portraits,*
   *two images of close-up detail and one close-up portrait.*

The requirements for the above assignment must be clarified with your tutor prior to undertaking any work. Tick the requirements below.

**Medium**   Black & white  [  ]      Colour negative  [  ]      Transparency  [  ]
(film)

**Format**   35mm  [  ]      Medium format  [  ]      Large format  [  ]
(camera)

**Presentation requirements** .................................................................................
(size of prints/slide presentation, etc.)

# Resources

*Editorial:-*
*National Geographic*
*Newspapers and magazines*

*Photographers:-*
*Bill Brandt, Brian Griffin, Sebastio Salgado.*
*East 100th Street - Bruce Davidson. Harvard University Press. Cambridge. 1970.*
*Pictures of People - Nicholas Nixon.* Museum of Modern Art. New York. 1988.
*Men Without Masks - August Sander.* New York Graphic Society. New York. 1973.
*One Mind's Eye - Arnold Newman.* Secker and Warburg. London. 1974.

# Gallery

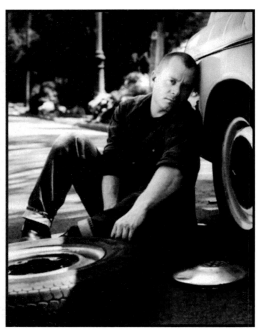

*Simon Sandlant*

*Melissa Bevan*

*MiAe Jeong*

# Gallery

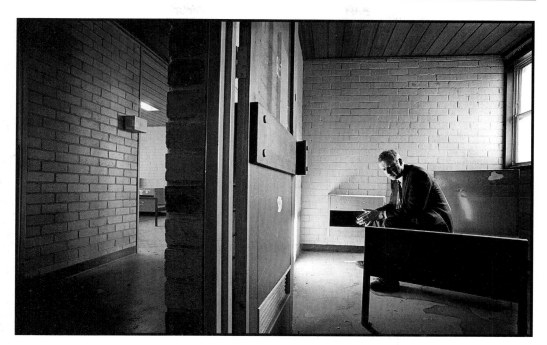

*Dianna Snape*

*Michael Mullan*

# Gallery

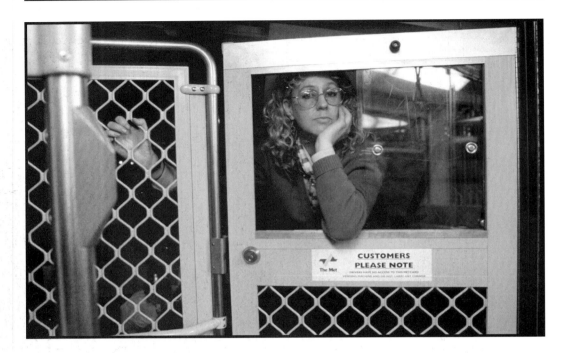

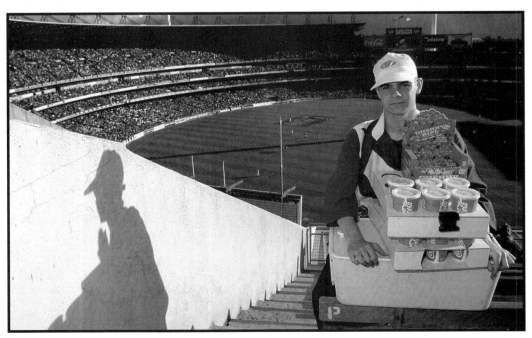

*Matthew Orchard*

# The Photographic Essay

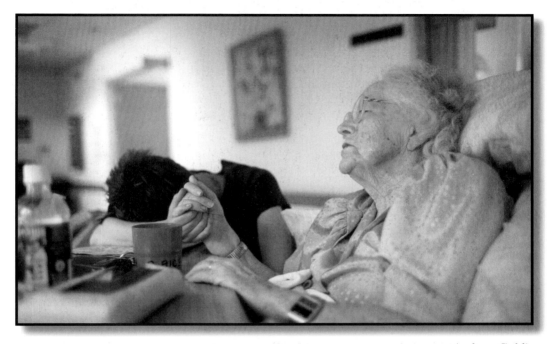

*Andrew Goldie*

## Aims

~ To increase knowledge of the historical development of the photographic essay.
~ To understand visual communication through narrative techniques.
~ To develop an awareness of receptive and projective styles of photography.
~ To understand the process of editing to clarify or manipulate communication.
~ To increase awareness of commercial, ethical and legal considerations.

## Objectives

~ Research contemporary and historical photo-essays, discussing communication, narrative and structure.
~ Research commercial aspects of production and publication.
~ Capture and create images illustrating involvement and connection with the subject.
~ Edit work collaboratively.

# Introduction

Documentary photography, photojournalism and reportage are all terms given to the craft of communicating personal experience through a sequence of images. It is a process of understanding, translation and expression. Decisive, dramatic, exotic or glamorous images are frequently used to illustrate the written story and attract the viewer to read the text. In a photographic story the images are organised to narrate the story. Individual images are like the pieces of a jigsaw puzzle. When the pieces are carefully assembled they create a greater understanding of the event or activity being recorded than a single image could hope to achieve. Text is secondary to the image and is often only used to clarify the content. A photographic story produced commercially is often a team project between a number of people (photographer, writer, editor and designer).

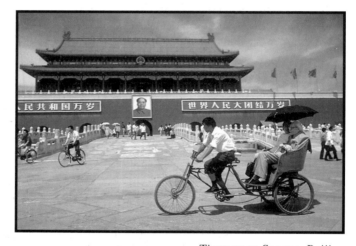

*Tiannemen Square, Beijing*

Although photography was invented in the last century the photographic story only emerged in the first half of this century. Even after the technology became available to include photography in the printed media many people remained sceptical as to the value it could make to news, entertainment and information. The craft of telling a story visually came of age in the 1930s when magazines appeared that gave priority to the photographic image over the written word. Life magazine was the first in 1936 and its emphasis on seeing rather than reading was clearly declared from the beginning:

> "to see life; to see the world; to eye witness great events; to watch the faces
> of the poor and the gestures of the proud; to see strange things - machines,
> armies, multitudes, shadows in the jungle and on the moon; to see man's
> work - his paintings, towers and discoveries; to see thousands of miles away,
> things hidden behind walls, and within rooms, things dangerous to come to;
> the women men love and many children; to see and take pleasure in seeing;
> to see and to be amazed;  to see and be instructed".

# A brief history

The development of photography as a vital component of the press was a slow process. The primary way of illustrating newspapers prior to photography was drawings in the form of wood cuts or engravings. The work of photographers such as Matthew Brady who photographed the American Civil War and Roger Fenton who photographed the Crimean War went unpublished at the time they created the images. Even after the invention of photography the printing presses were not capable of reproducing its many tones. The early photographers working for newspapers had their images translated into line drawings before inclusion into the paper.

It was the invention of the 'half-tone' in 1880 which made it possible to include photographic illustrations in the media. For the remainder of the century however, drawings remained the dominant illustrative medium.

*Photographic Van - Roger Fenton*

# The early years

In 1890 the photographer Jacob Riis working in New York produced one of the earliest photographic essays titled "How the other half lives". National Geographic magazine began using photographs in 1903 and by 1905 they had published an eleven-page photographically illustrated piece on the city Lhassa in Tibet. In 1908 the Freelance photographer Lewis W. Hine produced a body of work for a publication called "Charities and the Commons". The photographs documented immigrants in the New York slums. Due to the concerned efforts of many photographers working at this time to document the 'human condition' and the public's growing appetite for the medium, photography gradually became accepted. The first 'Tabloid Newspaper' (the 'Illustrated Daily News') appeared in the USA in 1919. By this time press cameras were commonly hand held and flash powder made it possible to take images in all lighting conditions.

# Coming of age

The 1930s saw a rapid growth in the development of the photographic story. The small 35mm Leica camera began to be mass produced. It was equipped with a fast lens and would take advantage of the high quality 35mm roll film developed for the movie industry.

During this decade the Farm Security Administration (FSA) commissioned photographers to document America in the grip of a major depression. Photographers including Russell Lee, Dorothea Lange, Ben Shahn, Carl Mydans, John Vachon, Walker Evans and Arthur Rothstein took many thousands of images over many years. This project provides an invaluable historical record of culture and society whilst developing the craft of Documentary photography.

*Migrant mother - Dorothea Lange*

# The photo agencies

In the same decade that the FSA was operating Life magazine was born and this saw a proliferation of like-minded magazines such as Picture Post in the UK. These publications dedicated themselves to showing 'life as it is'. Photographic agencies were formed in the 1930s and 1940s to help feed the public's voracious appetite for news and entertainment. The greatest of these agencies 'Magnum' was formed in 1947 by Henri Cartier Bresson, Robert Capa, Chim (David Seymour) and George Rodger. Magnum grew rapidly with talented young photographers being recruited to their ranks. The standards for honesty, sympathetic understanding and in-depth coverage were set by such photographers as W. Eugene Smith. Smith was a 'Life' photographer who produced extended essays staying with the story until he felt it was an honest portrayal of the people he photographed. In 1954 Life printed 'A man of mercy', a twenty-five image story that Smith had created about Albert Schweitzer. Smith felt that his story had been edited to heavily and resigned. He went on to produce the book 'Minamata' about a small community in Japan who were being poisoned by toxic waste being dumped into the waterways where the people fished. This was and remains today an inspirational photo-essay.

# A change in direction

Newspapers in the 1960s responded to public interest for illustrated stories by publishing weekend magazines. This provided a major outlet for the work from photo-agencies and freelance photographers. The war in Vietnam and the famines in Africa and Asia were displayed in all their graphic horror to a shocked public by photographers like Don McCullin. McCullin travelled the globe with the aim of raising people's awareness to distressing events in the world. He saw himself as the people's representative, the concerned witness of our times. Some people believe that these photographic images helped to change public opinion and bring an end to the war in Vietnam. The public could no longer be persuaded that war was glorious and honourable.

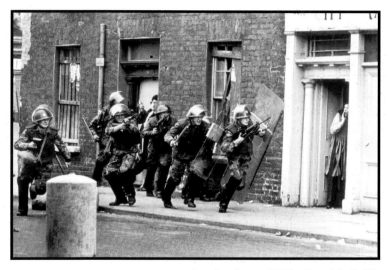

*Londonderry, 1970 - Don McCullin*

During the 1970s the major markets for photographic stories were already coming to an end. Television operating in 'real time' began to take over as the primary story telling medium and the advertisers contributing to magazines were feeling uncomfortable. The contrast between the glamour their products tried to convey and the horrors of war and famine placed side by side were proving incompatible for the industry.

During the 1980s and 90s magazines have steadily been moving towards escapism and glamour with the aim of creating a vehicle for 'lifestyle' advertising. When press photographers covered the Vietnam war, governments lost massive public support. In an effort to curtail such responses during the Falkland and Gulf wars Governments carefully controlled all press, including photographers. The shock-horror stories were conveniently removed from media circulation. The 'celebrity culture' has given rise to a pessimistic view that it is acceptable to produce news orientated stories for magazines so long as there are celebrities involved. An example of celebrity culture is the greater public interest in the African famines once many Pop and entertainment "stars" became involved in the fund-raising efforts.

# The present

Photojournalism has been criticised in recent years for its obsession with the exotic, unusual and remote. The Photographers who continue to work in the tradition of the great photojournalists, producing extended essays, have since turned their attentions to books, art galleries and the Internet as their outlet. Many prefer the editorial control this gives to the individual whilst others mourn the lack of financial gratification that magazine work used to provide. Photojournalists such as Sebastio Salgado and Gilles Peres however, continue to document history secure in the knowledge that 'Stills Photography' forms a major role in society's 'collective memory'. The moving image is often described as being ephemeral. Each hastily gathered image flashes by, quickly replaced by another. It is not easy to access the imagery once viewed and careful programming removes the contrast between information, entertainment and advertising. When we remember an important event in history we are more likely to remember the image from the newspaper than the TV coverage. To quote Harold Chapnick, the president of the Black Star photo agency:

**"To ignore photojournalism is to ignore history"**

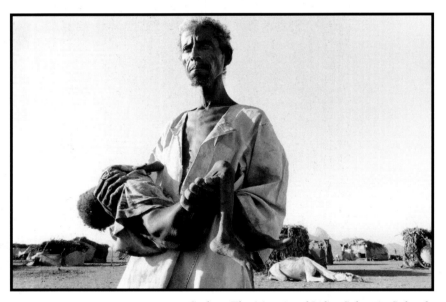

*Sudan: The Margin of Life - Sebastio Salgado*

# The future

The demands of the media and public for immediate news has led to further technological advances. The press photographer must now be conversant with the latest digital technology and be able to transmit images down phone cables or via satellite back to their agency or paper (it is not uncommon for a sports image to appear on newsprint before the actual game has even finished playing). On the other hand, many photographers continue to work with film and cameras that have changed little in over forty years, producing extended studies. These studies may reveal deep insight into our culture and society that will continue to form the valued historic documents of our times.

# Content

Photographic stories are the visual communication of personal experience, as such each story is potentially unique and is the ideal vehicle for personal expression. To communicate coherently and honestly the photographer must connect with what is happening. To connect the photographer should research, observe carefully, ask questions and clarify the photographer's personal understanding of what is happening. Unless the photographer intends to make the communication ambiguous it is important to establish a point of view or have an 'angle' for the story. This can be achieved by acknowledging feelings or emotions experienced whilst observing and recording the subject matter. All images communicate and most photographers aim to retain control of this communication. Photography can be used as a powerful tool for persuasion and propaganda and the communication of content should always be the primary consideration of the photographer.

*Michael Davies*

# Choice of subject matter

The most popular subject for the photographic story has always been the 'human condition'. This is communicated through experienced-based discovery. The aim is to select one individual or group of individuals and relate their story or life experience to the viewer. The story may relate the experience of a brief or extended period of time.

Finding a story, gaining permission to take images and connecting with the individuals once permission has been granted are some of the essential skills required to produce a successful story. Tracking down a story often requires curiosity, perseverance, motivation and patience. These skills are required by the majority of professional photojournalists who are freelance. Freelance photographers find, document and sell their own stories.

# The comfort zone

The 'comfort zone' is a term used to describe the familiar surroundings, experiences and people that each of us feel comfortable in and with. They are both familiar and undemanding of us as individuals. Photography is an ideal tool of exploration which allows us to explore environments, experiences and cultures other than our own. For professional photojournalists this could be attending a famine or a Tupperware party.

*Hairspray - Michael Davies*

The student photographer may feel they have to travel great distances in order to find an exotic or unusual story. Stories are however much closer at hand than most people realise. Interesting stories surround us. Dig beneath the surface of any seemingly bland suburban population and the stories will surface. People's triumphs, tragedies and traumas are evolving every day, in every walk of life. The interrelationships between people and their environment and their journey between birth and death are the never ending, constantly evolving resource for the documentary photographer. The photographer's challenge is to find and connect in a non-threatening and sympathetic way to record this. The student of photojournalism should strive to leave their personal 'comfort zone' in order to explore, understand and document the other. The photographer should aim to become pro-active rather than waiting to become inspired and find out what is happening around them.

# Activity 1

Find two meaningful photographic stories containing at least four images.
Write three hundred words answering the following questions:
What is being communicated in each story?
Have the captions influenced your opinion about what is happening?
Could a different selection of images alter the possible communication?
Make a list of ten photo-essays you could make in your own home town.
Describe briefly what you would hope to find out and communicate with your images.

# Constructing a story

How many movie films have you seen where the opening scene begins with a long and high shot of a town or city and moves steadily closer to isolate a single street or building and then a single individual.  This gives the viewer a sense of the place or location that the character inhabits.  A story constructed from still images often exploits the same technique. To extend and increase the communication of a series of images the photographer should seek to vary the way in which each image communicates.   There is a limit to the communication a photographer can achieve by remaining static, recording people from only one vantage point. It is essential that the photographer moves amongst the people exploring a variety of distances from the subject.  Only in this way will the photographer and the viewer of the story fully appreciate and understand what is happening.

**The photographer should aim to be a witness or participant at an activity or event rather than a spectator.**

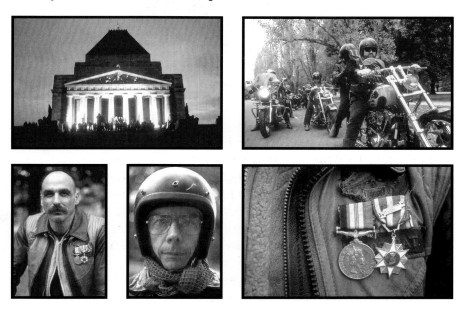

*Vietnam Vets at the Shrine of remembrance, Melbourne*

The images that create a well crafted photographic story can usually be divided or grouped into four main categories.  Not all stories contain images from all four categories but many editors expect to see them.  The categories are:

~ Overall environment or establishing image
~ Action image
~ Portrait or environmental portrait
~ Detail image

# Overall environment or establishing image

In order to place an event, activity or people in context with their environment it is important to step back and get an overview. If the photographer's essay is about a small coal-mining community in a valley, the viewer needs to see the valley to get a feeling for the location. This image is often referred to as the establishing shot but this does not necessarily mean that it is taken or appears first in the story. Often the establishing shot is recorded from a high vantage point and this technique sets the stage for the subsequent shots. In many stories it can be very challenging to create an interesting establishing image. An establishing image for a story about an animal refuge needs to be more than just a sign in front of the building declaring this fact. The photographer may instead seek out an urban wasteland with stray dogs and the dog catcher to set the scene or create a particular mood.

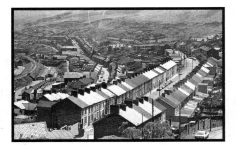
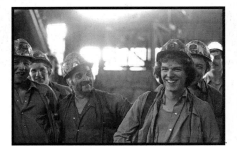
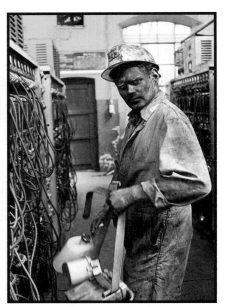

*Last working coal mine in the Rhondda valley*

# Action image or decisive moment

This category refers to a medium-distance shot capturing the action and interaction of the people or animals involved in the story. Many of the images the photographer captures may fall into this category, especially if there is a lot happening. It is however very easy to get carried away and shoot much more than is actually required for a the story to be effective. Unless the activity is unfolding quickly and a sequence is required the photographer should look to change vantage point frequently. Too many images of the same activity from the same vantage point are visually repetitive and will usually be removed by an editor.

# Portrait and environmental portraits

Portraits are essential to any story because people are interested in people and the viewer will want to identify with the key characters of the story. Unless the activity the characters are engaging in is visually unusual, bizarre, dramatic or exciting the viewer is going to be drawn primarily to the portraits. The portraits and environmental portraits will often be the deciding factor as to the degree of success the story achieves. The viewer will expect the photographer to have connected with the characters in the story and the photographs must illustrate this connection. The connection is aided by the use of standard and wide-angle lenses which encourage an interactive working distance.

Portraits may be made utilising a variety of different camera distances. This will ensure visual interest is maintained. Environmental portraits differ from straight head and shoulder portraits in that the character is seen in the location of the story. The interaction between the character and their environment may extend the communication beyond making images of the character and location separately.

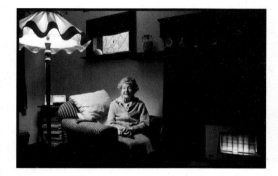 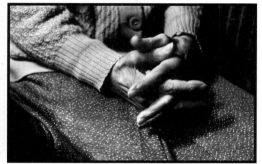

*Roly Imhoff*

# Close-up or detail image

The final category requires the photographer to identify significant detail within the overall scene. The detail is enlarged to either draw the viewer's attention to it or increase the amount or quality of this information. The detail image may be required to enable the viewer to read an inscription or clarify small detail. The detail image in a story about a crafts-person who works with their hands may be the hands at work, the fine detail of the artifact they have made or an image of a vital tool required for the process. For very small detail the photographer may require a macro lens or magnifying dioptres that can be attached to the existing lens. When the detail image is included with images from the other three categories visual repetition is avoided and the content is clearly communicated.

# Working styles

The photographer working on a story often has to switch between creating images (portraits, overall and detail images) and capturing images (action or decisive images). The styles of working are very different, each requiring a different mind-set, and photographers can find the switch between the two uncomfortable. Many photographers tackle the different images required for a photographic essay separately rather than alternating between the two styles of work.

## Receptive

Decisive images and action shots require a receptive approach where the photographer is focused solely on the environment and the activities, facial expressions or mannerisms of the characters. The photographer working receptively is not looking for specific images but is accepting circumstances 'as they are'. The photographer aims to increase their awareness of the activities and their surroundings as they change or unfold, many of the resulting images being photographed 'intuitively'.

The ability to photograph intuitively rests on the degree of familiarity photographers have with their equipment. Many professional photojournalists are able to operate their cameras instinctively without even looking to change shutter, aperture and exposure compensation controls. The camera becomes an extension of the hand and eye and the photographer is primarily concerned with seeing images rather than with the equipment necessary to capture them.

## Moving in close

The standard equipment for a photojournalist is a 35mm SLR equipped with a wide angle lens. Many photographers choose a fixed focal length lens rather than a zoom for the advantage that the wider maximum apertures afford in low light. Wide angle lenses are chosen above standard and telephoto lenses due to the steep perspective they give the images when working very close to the subject. The steep perspective and the relative position of the photographer to the action has the effect of involving the viewer. Viewers feel like participants rather than spectators.

## Activity 2

Research a photographic essay where the photographer has made extensive use of a wide angle lens.

Discuss the composition and communication of each image.

Without resorting to the use of telephoto lenses, take ten images of people engaged in a group activity.

Create depth by the use of foreground, middle distance and distant subject matter.

Make use of edge of frame detail to create the feeling of involvement.

# The photographer's presence

When the photographer is working at close range it is worth considering the impact this presence has on the event or activity being photographed. Most photojournalists practice the art of working unobtrusively to minimise the effect on their surroundings. This can be achieved in the following ways:

- ~ Raise the camera to take the image not to find the image.
- ~ Be decisive, don't procrastinate.
- ~ Minimise the amount of equipment being carried - two bodies and three lenses is sufficient.
- ~ Carry the camera in the hand rather than around the neck - (use a wrist strap or the neck strap wrapped around the wrist).
- ~ Reduce the size of the camera bag and do not advertise the cameras that are inside.
- ~ Use the ambient light present - use fast film and fast lenses rather than flash.
- ~ Choose appropriate clothing for the location or company that you are in.
- ~ Move with the activity.
- ~ Familiarise yourself with the location and/or the people prior to capturing the images.

# Shooting ratios

A photographer capturing images spontaneously should not expect to contribute all of the images to the final story. This will lead to undershooting and missed opportunities. The photographer cannot hope to wait for the single most dramatic moment of the event or activity before releasing the shutter. This would lead to a projective approach that is used when a photographer is creating rather than capturing images. The photographer cannot control events only predict them as they are about to happen. Recording images as an event unfolds or as the photographer changes vantage point means that many images will be captured that will be not be used. This is called a 'shooting ratio'. For every image used, ten may be discarded as unnecessary to the narrative of the story (a shooting ratio of 1:10). The value of each image is not assessed as it is captured but later during the editing process. The unused images are not to be seen as wasted or failed images but as part of the working process of photojournalism.

# Activity 3

Make a list of the ideal range of equipment you would take to record a crowded event in a foreign country where spontaneous and decisive images are required.

List brand names and the cost of each item new or second-hand.

List the cost of insuring these items against 'all risks' and theft from a locked room or vehicle.

Indicate how you would process the films on location at the end of each day to monitor your progress.

# Projective

In creating images the photographer is able to plan and arrange either the timing, the subject matter or location so that the resulting imagery fits the photographer's requirements for communication of content. Photographers illustrate what is often in their minds-eye. To create images in collaboration with the characters of the story a connection must be made. For this to happen the photographer must overcome the fear that most people have about talking to strangers. It is a little like door to door sales. The first contact is always the most nerve racking. The more you connect, the easier it becomes.

*Liam Handasyde*

# An honest document

Some people find the projective approach (used by many photojournalists) controversial, and do not like the degree of manipulation involved in assembling a story which is claiming to be an accurate and honest record or document. On the other hand all photographs are a manipulation of reality to some degree. The selection of timing and framing is a manipulation in itself. As soon as a character within a story makes eye contact with the photographer the event has been changed or manipulated. Without manipulation and interaction the resulting stories can appear detached and shallow. Each individual photographer must weigh up the advantages and disadvantages of working in a projective style. The photographer must personally feel comfortable that the story being created is an accurate translation of events, people and circumstances. Photographs are however just that, a translation, and each story teller will tell their tale differently.

# Editing

The aim of editing work is to select a series of images from the total production to narrate an effective story. Editing can be the most demanding aspect of the process requiring focus and energy. The process is a compromise between what the photographer originally wanted to communicate and what can actually be said with the images available.

## Editorial objective

The task of editing is often not the sole responsibility of the photographer. The task is usually conducted by an editor or in collaboration with an editor. The editor considers the requirements of the viewer or potential audience whilst selecting images for publication. The editor often has the advantage over the photographer in that they are less emotionally connected to the content of the images captured. The editor's detachment allows them to focus on the ability of the images to narrate the story, the effectiveness of the communication and the suitability of the content to the intended audience.

## The process
~   Images are viewed initially as a collective. A typical process is listed as follows:
~   All the proof sheets, prints or transparencies are spread out on a table or light box.
~   All of the visually interesting images and informative linking images are selected and the rest are put to one side.
~   Similar images are grouped together and the categories (establishing, action, portrait and detail) are formed.
~   Images and groups of images are placed in sequence in a variety of ways to explore possible narratives.
~   The strength of each sequence is discussed and the communication is established.
~   Images are selected from each category that reinforce the chosen communication.
~   Images that contradict the chosen communication are removed.
~   Cropping and linking images are discussed and the final sequence established.
~   Further work may include the input of a graphic designer who will discuss layout and the relative size and position of images on the printed page.

## Activity 4

Take two rolls of film of a chosen activity or event taking care to include images from all of the four categories discussed in this chapter.
Edit the work with another student who can take on the role of an editor.
Edit and sequence the images to the preference of the photographer and then again to the preference of the editor.
Discuss the editing process and the differences in outcome of both the photographers and editors final edit.

# Ethics and law

Will the photograph of a car crash victim promote greater awareness of road safety, satisfy morbid curiosity or just exploit the family of the victim?  If you do not feel comfortable photographing something, question why you are doing it.  A simple ethical code of practice used by many photographers is:  **'The greatest good for the greatest number of people'.** Papparazzi photographers hassle celebrities to satisfy public curiosity and for personal financial gain.  Is the photographer or the public to blame for the invasion of privacy?

The first legal case for invasion of privacy was filed against a photographer in 1858.  The law usually states that a photographer has the right to take a picture of any person whilst in a public place so long as the photograph:

> ~ is not used to advertise a product or service.
> ~ does not portray the person in a damaging light (called deformation of character).

If the photographer and subject are on private property the photographer must seek the permission of the owner.  If the photograph is to be used for advertising purposes a model release should be signed.

Other legal implications usually involve the sensitivity of the information recorded (military, political, sexually explicit, etc.) and the legal ownership of copyright.  The legal ownership of photographic material may lie with the person who commissioned the photographs, published the photographs or the photographer who created them.  Legal ownership may be influenced by country or state law and legally binding contracts signed by the various parties when the photographs were created, sold or published.

## Digital manipulation

Images are often distributed digitally which allows the photographer or agency to alter the images subtly in order to increase their commercial potential. Original negatives or transparencies may never be sighted by an editor.  A photographer, agency or often the publication itself may enhance the sharpness, increase the contrast, remove distracting backgrounds, remove information or combine several images to create a new image. What is legally and ethically acceptable is still being established in the courts of law.  The limits for manipulation often rests with the personal ethics of the people involved.

## Activity 5

Discuss the ethical considerations of the following:
> ~ Photographing a house fire where there is the potential for loss of life.
> ~ Photographing a celebrity who is on private property from public property.
> ~ Manipulating a news image to increase its commercial viability.

Research and discuss the ownership of copyright for the following:
> ~ Commissioned work.
> ~ Noncommissioned work sold to a company or organisation.

# Distribution and sale of photo-essays

The majority of photojournalists are either freelance or work for agencies. Freelance photographers are commissioned to cover stories for a wide variety of media and corporate publications. Photojournalists also self assign. They seek out and research possible commercial stories and then sell the finished piece to a publication. Many photographers contact publications with the idea or concept for a story before taking the images. They complete the story when they find a publication interested in the idea. Newspapers cannot hope to cover all world news and feature stories using staff photographers only. They therefore rely heavily on input from freelance photographers. The material is brought in from photo and news agencies, wire services, stock libraries and through direct contact with photographers.

In order to succeed a freelance photojournalist usually requires the following skills:

- ~ Curiosity, self motivation and patience to find and complete a story.
- ~ Knowledge of publications currently buying photographic material (a media directory with contact names, addresses and circulation is usually available in large libraries).
- ~ Commercial requirements for stories (these include image format, publication deadlines, content, length, style and copy).

## Titles and copy

All images need to be titled prior to submission. This can achieved with labels or applied with a fine indelible pen directly to the slide mount or reverse side of the print. Titles usually include the following information:

- ~ Location and date.
- ~ A brief description of the content including names of people.
- ~ Photographer's name.

Accompanying copy is sometimes prepared by a staff writer working from the factual information provided by the photographer or is submitted by the photographer along with the images. Photographers often team up with a writer on projects and submit the work as a team effort. The average length of each story and the style for written copy (humorous, factual, etc.) needs to be researched prior to submission.

## Activity 6

Research possible distribution and sale of a photo-essay.
Locate one local photo-agency, one stock library and one photographic archive.
Research the possibility of submitting one essay or image to a magazine to which you currently subscribe.

# Assignments

Produce a ten image photo-essay giving careful consideration to communication and narrative technique. For each of the five assignments it is strongly recommended that students:

~ Treat each assignment as an extended project.
~ Choose activities, events or social groups that are repeatedly accessible.
~ Avoid choosing events that happen only once or run for a short period of time.
~ Approach owners of private property in advance to gain relevant permission.
~ Have a back-up plan should permission be denied.
~ Introduce yourself to organisers, key members or central characters of the story.

1. Document manual labour or a profession.
2. Document a minority, ethnic or fringe group in society.
3. Document an aspect of modern culture.
4. Document an aspect of care in the community.
5. Document a political or religious group.

The requirements for the above assignment must be clarified with your tutor prior to undertaking any work.  Tick the requirements below.

**Medium**   | Black & white |   | | Colour negative |   | | Transparency |   |
(film)

**Format**   | 35mm |   | | Medium format |   | | Large format |   |
(camera)

**Presentation requirements**  ....................................................................................
(size of prints / slide presentation etc.)

# Resources

National Geographic magazine.
American Photo magazine.

*Farewell to Bosnia - Gilles Peress.*  Scalo. New York. 1994.
*In This Proud Land - Stryker and Wood.*  New York Graphic Society. New York. 1973.
*Minamata - W. Eugene and Aileen Smith.*  Chatto and Windus. London. 1975.
*Sleeping with Ghosts - Don McCullin.*  Vintage. London. 1995.
*The Concerned Photographer - Cornell Capa.*  Thames and Hudson. London. 1972.
*Workers - Sebastio Salgado.* Phaidon Press. London. 1993.

Black Star photo agency - http://www.blackstar.com
FSA web site - http://www.memory.loc.gov/ammem/fsowhome.html

# Gallery

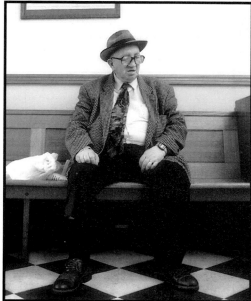

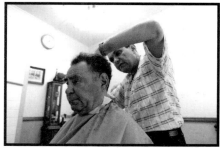

*Michael Davies*

# Gallery

*Kate Mills*

# Art Direction

*Mark Galer*

## Aims

~ To develop knowledge and understanding of the process of working with an art director, art direction terminology and outcomes.
~ To develop an awareness of how photography is influenced by the demands of a layout and the requirements of a client.

## Objectives

~ **Research** - Produce a Visual Diary that contains the references and visual information that influenced the approach taken to each activity.
~ **Discussion** - Exchange ideas and opinions with other students and lecturers related to the activities you are asked to research.
~ **Practical work** - Produce examples of research information relevant to the activities, process, terminology and outcomes of photographic illustration and art direction.

# Introduction

Most commercial photographic projects, whether editorial or advertising will involve working under art direction. This involves working to a specific set of guidelines set by the art director or designer and for most of the time having that person 'looking over your shoulder'. The art director is responsible for more than just ensuring you take a good photograph.

## Working with art direction

Most commercial assignments are at the request of someone else - the client. It is this commissioning process that makes it the photographer's role to supply the client with the photograph they are prepared to pay for. Because they are paying they have a say in how you photograph the subject, whether it be a car, themselves or someone's dog. It is important to take note of their requests and supply a photograph that complies with their requirements. The process should be a combination of the skills of all the parties involved.

Editorial assignments have less contrived and predetermined guidelines within which a photographer has to compose and produce a photograph. The brief is usually governed by the number of photographs per page and an outline of the general content of the subject matter in relation to the text.

With an advertising agency or designer, where the role of the art director is very much an integral part of the production of the final photograph, the requirements are far more precise and demanding.

## Art directors and designers

Before a photographer is commissioned to photographically illustrate an advertisement, the art director/designer would have submitted countless ideas at numerous creative meetings. These meetings involve the creative team (art director and copy writer) the creative director (leader of all creative teams within an advertising agency) and in the initial and final stages, the client. This process can be long and arduous. Many ideas will be submitted but only one will be accepted by all parties. By the time the surviving idea reaches the photographer the idea and layout have become very refined and precise. It is imperative that the photographer produces exactly what is wanted. In these circumstances photographer and art director/designer work as a team so a result acceptable to a third party (the agency's client) is achieved. Working to an agreed plan, known as a layout, is the blueprint all concerned follow in order to produce an end result acceptable to all.

## Activity 1

Using magazines and newspapers collect a series of advertisements created on location that have varying amounts of art direction and copy writing.

Compile in your Visual Diary advertisements you consider more effective than others.

Discuss with other students and lecturers the visual merits and failures of each.

# Layouts

A layout is the format decided by an art director/designer into which the photograph, headline and body copy (text) have to combine to form an integrated whole. It is a guide to ensure all the elements visually fit together and become a piece of art work that serves, in the case of advertising, the purpose of attracting attention to the product. Rarely does the photographer have the opportunity to take photographs and have the art director incorporate headline and body copy later. It is nearly always the other way around.

The graphic designer and art director's role is to take all the components, (photograph, headline, body copy, client logo) and assemble them in a cohesive form. The finished piece of art work must be acceptable to the client and capable of being produced and printed to budget.

After the initial briefing at which the photographer is informed of all the requirements of the photograph, most clients will request a written estimate of costs to produce the photograph. Upon acceptance of this quote a period of time (pre-production) is allowed in which to prepare for the shoot, this involves the complete organisation of all the elements required to be in the final photograph. It is at this stage the photographer should offer information and advice regarding the practicalities of the layout. If it is obvious to the photographer that elements of the layout are not achievable at a practical or financial level it should be mentioned at the briefing or during the pre-production period. **Do not leave it until the day of the shoot.** Throughout this process it is important to constantly relate back to the layout and the brief. It is better to oversupply equipment and props than to be short on the day when your reputation as a photographer and organiser is on display. Leave nothing to chance. Organise.

# Organisation

Check the availability of the intended location. Is it public or private property? Ensure you are granted permission well in advance. Check the natural lighting during the time of day you intend the shoot to take place. Check the weather forecast prior to the shoot and arrange alternative locations for back-up.

Do not assume all the equipment will work. Check everything first. Do not limit your choice of lenses and associated equipment. Assume the art director may change his mind or request an adaptation to his original idea as he sees the photograph take shape. If you suggest changes ensure you can fulfil your idea. If the brief asks for black and white ensure plenty of black and white **and** colour is available.

# Activity 2

Collect four advertising or editorial photographs using four very different locations.
Discuss the contribution the location makes to the concept in each image.
Does the product or concept sometimes determine the aesthetic approach taken by the photographer and the choice of location?

# Commercial requirements

## Concept and communication

Photographs used in completed pieces of art work are rarely random images. They are images that relate to the message the art director is attempting to get across to the public. It is essential to fully understand what the art director is trying to say with this combination of words and pictures. Suggestions by the photographer are usually welcome if there is a genuine attempt to improve on the outcome. Suggesting radical changes will meet with resistance. This may not necessarily be because the art director disagrees with you but because any major change would require a re-submission to the agency of any new idea that differs from what the client has agreed to pay for.

This is valid in any form of commissioned photography. If someone is paying you to photograph their dog in his favourite kennel suggest variations upon this theme but do not be surprised if you meet resistance. It may seem like a great idea to you to suggest that the dog be photographed in a bath full of bubbles but the client may hate how the dog looks when it is wet. Do not feel obliged to make any suggestions if it is obvious that the client has a firm opinion of what they expect from you. Judge each job on its merits.

*Double-page spread*

## Format

As well as creative constraints there are physical restrictions placed upon the photographer when it comes to composition. If the layout is a single full page advertisement the camera should be orientated to a portrait format (vertical). A double-page spread would see the camera set to landscape (horizontal) and allowance made for the inclusion of a gutter (where the staples go) when composing the photograph. A double-page spread should look as if it is one photograph although made up of two separate but connected images. A billboard would be horizontal format, an in store poster could be either. This is a guide where the rules can change. Once the orientation and format has been decided allowance for areas within the composition must be left for the headline, body copy and the printing process.

# Text and bleed

In a single full page advertisement where the photograph is printed to the edge of the page the text (words) will be printed over the image. The choice of typeface used to print this text is chosen by the art director. The positioning of these various pieces of text (headline, body copy) is known as typography. In a single page advertisement where the photograph is contained within the page the typography will appear on the page and not over the image. These rules also apply to double-page spreads, twenty-four sheet posters (billboard), point of sale (seen at the end of supermarket aisles), in-store posters, catalogues and any form of finished art where there is a combination of photography and words.

Bleed is the term that refers to the amount of excess image area allowed around the edges of a photograph that will disappear in the printing process. This is done to eliminate the possibility of white edges appearing when the finished piece of art work is scanned and printed. If the art work is slightly greater in size than the paper it is being printed on, any chance of the edges of the paper not being printed has been reduced. This is especially important with very large print runs.

*Single page - Sabina Bukowski*

*Single full page*

# Activity 3

Find examples of the various photographic formats used in magazine and newspaper advertising.

Find examples where different formats have been used for the same advertisement (e.g. single page and billboard).

Discuss how each photographic illustration has been designed with consideration for both the format and the text.

# Assignment

For this assignment you are required to work in partnership with another student.
For **one** of the following briefs produce a layout and art direct your partner to create a photograph to illustrate your concept.
For the second brief create a photograph under art direction to illustrate your partner's layout.

1. **Milk** - Communicate a new product positioning for milk as a remarkable drink that helps you get the most out of life.  Provide an attractive emotional image for milk, taken on location, by linking the rational benefits of health, refreshment and energy to the emotional values of the target audience's lifestyle.  Target audiences should be either young males or teenage girls.
Produce one magazine advertisement that is either a full page or double-page spread.

2.  **Wool** - The perception of wool is still reflected as traditional, formal, even old fashioned and lacking in newness and to be worn only for the extreme winter months.  Wool is not associated with coolness, lightness and summer.  Convey to the target audience, with an image taken on location, the message that lighter wool garments are more casual, youthful, innovative, lightweight, comfortable and easy to care for - a fabric for all seasons.
Primary target is both men and women, aged 18-35 (best typified as the jeans generation), who are forward-thinking, seek casual wear and who are interested in fashion trends.
Produce one magazine advertisement that is either a full page or double-page spread.

The requirements for the above assignment must be clarified with your tutor prior to undertaking any work.  Tick the requirements below.

**Medium** | Black & white | | Colour negative | | Transparency |
(film)

**Format** | 35mm | | Medium format | | Large format |
(camera)

**Presentation requirements** ......................................................................................
(size of prints/slide presentation etc.)

# Resources

*Photography - from the Graphis Annuals.*  Page One Publishing.  Singapore. 1994
*Best of Graphis Advertising 1.*  Page One Publishing.  Singapore.  1993
*Best of Graphis Advertising 2.*  Page One Publishing.  Singapore.  1993
*Basic design and layout - Alan Swann.*  Phaidon Press.  London.  1993
*The Association of Photographers. Leonard Street.*  London EC 2.  UK
*The Association of Photographers. The Awards.*  British Media Publications.

# Gallery

*Sabina Bukowski*

# Gallery

*Melanie Ryan*

# Glossary

**Analyse/Analysis**  To examine in detail.

**Ambient light**  The natural or artificial continuous light that exists before the photographer introduces additional lighting.

**Aperture**  A circular opening in the lens that controls light reaching the film.

**Averaging meter**  A meter that measures the light over a broad area and averages the intensity to indicate one exposure value.

**Backlit**  A subject illuminated from behind.

**Balance**  A harmonious or stable relationship between elements within the frame.

**Blurred**  An image or sections of an image that are not sharp. This can be caused through inaccurate focusing, shallow depth of field or a slow shutter speed.

**Bracketing**  Over and underexposure either side of a meter-indicated exposure

**B setting**  The shutter speed setting B allows the shutter to stay open as long as the shutter release remains pressed.

**Bounced light**  Lighting that is reflected off a surface before reaching the subject.

**Cable release**  A cable that allows the shutter to be released without shaking the camera when using slow shutter speeds.

**Camera shake**  Blurred image caused by camera movement during the exposure.

**Close-up lens**  A one element lens that is attached to the front of the camera's lens. This allows the image to be focused when the camera is close to a subject.

**Close down**  A term referring to the action of making the lens aperture smaller.

**Closest point of focus**  Minimum distance from subject where sharp focus can be obtained.

**Composition**  The arrangement of shape, tone, line and colour within the boundaries of the image area.

**Compression**  Underdevelopment allowing a high subject brightness range to be recorded on film.

**Contact print**  A print which displays images from a group of negatives.

**Context**  The circumstances relevant to something under consideration.

**Contrast**  The difference in brightness between the darkest and lightest areas of the image or subject.

**Converging perspective**  Parallel lines that are seen to converge as they recede towards the horizon.

| | |
|---|---|
| **CPU** | Central processing unit used to compute exposure. |
| **Crop** | Reduce image size to enhance composition or limit information. |
| **Daylight** | Combined light from both sunlight and skylight.  5500K |
| **Decisive moment** | The moment when the arrangement of the moving subject matter in the viewfinder of the camera is composed to the photographer's satisfaction. |
| **Dedicated flash** | A flash unit that is fully linked to the camera's electronics and uses the camera's own TTL light meter to calculate correct exposure. |
| **Density** | The measure of opacity of tone on a negative. |
| **Densitometer** | An instrument to measure the density of tones on film or paper. |
| **Depth of field** | The zone of sharpness variable by aperture, focal length or subject distance. |
| **Depth of field preview** | A mechanism which closes the aperture to the selected setting whilst viewing the image. |
| **Diagonal** | A slanting line that is neither horizontal nor vertical. |
| **Differential focusing** | Use of focus to highlight specific subject areas |
| **Diffused light** | Light that is dispersed (spreads out) and is not focused. |
| **Diffuser** | Material used to disperse light |
| **Digital image** | A computer-generated photograph composed of pixels (picture elements) rather than silver. |
| **Diminishing perspective** | A sense of depth in a two-dimensional image provided by the reduced size of subjects as they recede into the distance. |
| **Dioptres** | Units of measurement for close-up lenses. |
| **Dissect** | To cut into pieces.  The edge of the frame can dissect a familiar subject into an unfamiliar section. |
| **Dynamic tension** | An image which lacks either balance or harmony and where visual elements cause the eye to move out of the image. |
| **DX coding** | Bar coded film speed rating. |
| **Edit** | Select images from a larger collection to form a sequence or theme. |
| **Emulsion** | Light sensitive layer on film or paper. |
| **EV** | Exposure value.  A numerical system of indicating camera exposure without referring to either shutter speed or aperture. |
| **Evaluate** | Assess the value or quality of a piece of work. |
| **Exposure** | Combined effect of intensity and duration of light on a light sensitive material. |
| **Exposure index** | An accurate measure of a film's sensitivity to light. |
| **Expansion** | The separation of zones by extending the processing time. |

| | |
|---|---|
| **Exposure compensation** | To increase or decrease the exposure from a meter-indicated exposure to obtain an appropriate exposure. |
| **Exposure factor** | Indication of the increase in light required to obtain a correct exposure. |
| **Exposure meter** | Device for the measurement of light. |
| **Extreme contrast** | A subject brightness range that exceeds the film's ability to record detail in all tones. |
| **F-numbers** | A sequence of numbers given to the relative sizes of aperture opening.  F-numbers are standard on all lenses.  The largest number corresponds to the smallest aperture and vice versa. |
| **Fast film** | A film that is very light sensitive compared to other films.  Fast film has a high ISO number and can be used when the level of ambient light is low. |
| **Field of view** | The area visible through the camera's viewing system. |
| **Figure and ground** | The relationship between subject and background. |
| **Fill flash** | Flash used at a reduced output to lower the subject brightness range. |
| **Fill** | Use of light to increase detail in shadow area. |
| **Film speed** | A precise number or ISO rating given to a film indicating its degree of light sensitivity.  See 'Fast film' and 'Slow film'. |
| **Filter** | Treated or coloured glass or plastic placed in front of the camera lens to alter the transmission of different wavelengths of light thereby altering the final appearance of the image. |
| **Filter factor** | A number used to indicate the effect of the filter's density on exposure. |
| **Flare** | Unwanted light, scattered or reflected within the lens assembly creating patches of light and degrading image contrast. |
| **Focal length** | Distance from the optical centre of the lens to the film plane when the lens is focused on infinity.  A long focal length lens (telephoto) will increase the image size of the subject being photographed.  A short focal length lens (wide angle) will decrease the image size of the subject. |
| **Focal plane shutter** | A shutter directly in front of the film plane. |
| **Focal point** | Point of focus at the film plane or point of interest in the image. |
| **Focusing** | The action of creating a sharp image by adjusting either the distance of the lens from the film or altering the position of lens elements. |
| **Format** | The size of the camera or the orientation/shape of the image. |
| **Frame** | The act of composing an image.  See 'Composition'. |
| **Golden section** | A classical method of composing subject matter within the frame. |

| | |
|---|---|
| **Grain** | Tiny particles of silver metal or dye which make up the final image. Fast films give larger grain than slow films. Focus finders are used to magnify the projected image so that the grain can be seen and an accurate focus obtained. |
| **Grey card** | Card which reflects 18% of incident light. The resulting tone is used by light meters as a standardised mid-tone. |
| **Guide number** | A measurement of the power of flash relative to the film speed being used. Divide the guide number by the maximum aperture available to find the maximum working distance in metres for 100 ISO film. |
| **Half-tone** | A system of reproducing the continuous tone of a photographic print by a pattern of dots printed by offset litho. |
| **Hard light** | A light source which appears small to the human eye and |
| **High key** | produces directional light giving well-defined shadows, e.g. direct sunlight or a naked light bulb. |
| **Highlight** | An image where light tones dominate. Area of subject receiving highest exposure value. |
| **Horizontal** | A line that is parallel to the horizon. |
| **Hot shoe** | Plug in socket for on-camera flash. |
| **Incident light reading** | A measurement of the intensity of light falling on a subject. |
| **Invercone** | The trade name for a small plastic diffusing dome placed over the light sensitive cell of a hand held meter in order to take an incident light meter reading. |
| **Inverse square law** | A mathematical formula for measuring the fall-off (reduced intensity) of light over a given distance. |
| **ISO** | International Standards Organisation. A numerical system for rating the speed or relative light sensitivity of a film. |
| **Infrared film** | A film which is sensitive to wavelengths of light longer than 720nm but which are invisible to the human eye. |
| **Inverse square law** | A law stating the relative fall-off of light over a given distance. If the distance of the subject from the light source is doubled the light striking the subject is one-fourth as strong. |
| **Juxtapose** | Placing objects or subjects within a frame to allow comparison. |
| **Key light** | The main light casting the most prominent shadows |
| **Latitude** | Ability of the film to record the brightness range of the subject. |
| **Leaf shutter** | Overlapping blades built into the lens assembly. |
| **LED** | Light-emitting diode. Used in the viewfinder to inform the photographer of exposure settings . |

| | |
|---|---|
| **Lens** | An optical device usually made from glass that focuses light rays to form an image on a surface. |
| **Lighting ratio** | Relationship of intensity between the light from two sources falling on the same subject. |
| **Light meter** | A device that measures the intensity of light so that the optimum exposure for the film can be obtained. |
| **Long lens** | Lens with a reduced field of view to normal. |
| **Low key** | An image where dark tones dominate. |
| **Macro** | Extreme close-up. |
| **Matrix metering** | A reflected light meter reading which averages the readings from a pattern of segments over the subject area. Bias may be given to differing segments according to preprogrammed information. |
| **Maximum aperture** | Largest lens opening. |
| **MIE** | Meter-indicated exposure. |
| **Minimum aperture** | Smallest lens opening. |
| **Multiple exposure** | Several exposures made onto the same frame of film or piece of paper. |
| **Negative** | An image on film or paper where the tones are reversed, e.g. dark tones are recorded as light tones and vice versa. |
| **Neutral density filter** | Reduces the amount of light reaching the film, enabling the photographer to choose large apertures in bright conditions or extend exposure times. |
| **Objective** | A factual and non-subjective analysis of information. |
| **Opaque** | Not transmitting light. |
| **Open up** | Increasing the lens aperture to let more light reach the film. |
| **Overall focus** | An image where everything appears sharp. |
| **Pan** | To follow a moving subject. |
| **Perspective** | The apparent relationship of distance between visible objects thereby creating the illusion of depth in a two-dimensional image. |
| **Perspective compression** | Flattened perspective created by the use of a telephoto lens and distant viewpoint. |
| **Photoflood** | Tungsten studio lamp with a colour temperature of approximately 3400K. |
| **Polarising filter** | A grey looking filter used to block polarised light. It can remove or reduce unwanted reflections from some surfaces and can increase the colour saturation and darken blue skies. |
| **Portrait lens** | A telephoto lens used to capture non-distorted head and shoulder portraits with shallow depth of field. |
| **Portrait mode** | A programmed exposure mode that ensures shallow depth of field. |

**Previsualisation**    The ability to decide what the photographic image will look like before exposure.

**Pushing film**    The film speed on the camera's dial is increased to a higher number for the entire film. This enables the film to be used in low light conditions. The film must be developed for a longer time to compensate for the underexposure.

**Push-processing**    Increasing development to increase contrast or to compensate for underexposure or films that have been rated at a higher speed than recommended.

**Reciprocity failure**    Inability of film to behave predictably when selecting very long or very brief shutter speeds.

**Reflectance range**    Subject contrast measured in flat light (no shadows).

**Reflector**    A surface used to reflect light in order to soften harsh shadows.

**Refraction**    The change in direction of light as it passes through a transparent surface at an angle.

**Resolution**    A measure of the degree of definition, also called sharpness.

**Rule of thirds**    An imaginary grid which divides the frame into three equal sections vertically and horizontally. The lines and intersections of this grid are used to design an orderly composition.

**Saturation (colour)**    Intensity or richness of colour hue.

**SBR**    See 'Subject brightness range'.

**Scale**    A ratio of size. The relationship of size between the image and the real subject, e.g. something that appears as one centimetre in the image that is ten centimetres in real life is said to have a scale of 1:10.

**Selective focus**    The technique of isolating a particular subject from others by using a shallow depth of field.

**Self-timer**    A device which delays the action of the shutter release. This can be used for extended exposures when a cable release is unavailable.

**Sharp**    In-focus. Not blurred.

**Shutter**    A mechanism that controls the accurate duration of the exposure.

**Shutter-priority**    Semi-automatic exposure mode. The photographer selects the shutter speed and the camera sets the aperture.

**Silhouette**    The outline of a subject seen against a bright background.

**Skylight filter**    Used to reduce or eliminate the blue haze seen in landscapes. It does not affect overall exposure so it is often used to protect the front lens element from damage.

**Slave**    Remote firing system for multiple flash heads.

**Slow film**    A film that is not very sensitive to light when compared to other films with a higher ISO number. The advantage of using a slow film is its smaller grain size.

| | |
|---|---|
| **SLR camera** | Single Lens Reflex camera.  The image in the viewfinder is essentially the same image that the film will see.  This image prior  to taking the shot is viewed via a mirror which moves out of the way when the shutter release is pressed. |
| **Small format** | Camera with format dimensions of 24 x 36mm or smaller. |
| **Soft light** | This is another way of describing diffused light which comes from  a broad light source and creates shadows that are not clearly defined. |
| **Spot meter** | Meter capable of reading the reflectance of a small area of a selected tone. |
| **Standard lens** | A lens that gives a view that is close to normal visual perception. |
| **Steep perspective** | Exaggerated diminishing perspective created by a viewpoint in close proximity to the subject with a wide angle lens. |
| **Stop down** | Decreasing the aperture of the lens to reduce the exposure. |
| **Straight photography** | Photographic images that have not been manipulated. |
| **Subject brightness range** | A measurement of the total contrast range of the subject from the brightest to the darkest tone within the image area. |
| **Subjective analysis** | Personal opinions or views concerning the perceived communication and aesthetic value of an image. |
| **Symmetry** | Duplication of information either side of a central line to give an image balance and harmony. |
| **Sync lead** | A lead from the camera to the flash unit which synchronises the firing of the flash and the opening of the shutter. |
| **Sync speed** | The fastest shutter speed available, for use with flash, on a camera with a focal plane shutter.  If the sync speed of the camera is exceeded when using flash the image will not be fully exposed. |
| **Telephoto lens** | A long focal length lens.  Often used to photograph distant subjects which the photographer is unable to get close to.  Also used to flatten apparent perspective and decrease depth of field. |
| **Thematic images** | A set of images with a unifying idea. |
| **Tone** | A tint of colour or shade of grey. |
| **Transparent** | Allowing light to pass through. |
| **TTL meter** | Through-the-lens reflective light meter.  This is a convenient way to measure the brightness of a scene as the meter is behind the camera lens. |
| **Tungsten light** | A common type of electric light such as that produced by household bulbs and photographic lamps.  When used with daylight colour film a blue filter can be used to prevent the resulting prints looking orange. |

| | |
|---|---|
| **Uprating film** | The action of "pushing" the film, i.e. the film speed on the camera's dial is increased to a higher number for the entire film. This enables the film to be used in low light conditions. The film must be developed for longer to compensate for the underexposure. |
| **UV filter** | A filter used to absorb ultraviolet radiation. The filter appears colourless and is often left on the lens permanently to protect the lens. |
| **Vantage point** | A position in relation to the subject which enables the photographer to compose a good shot. |
| **Vertical** | At right angles to the horizontal plane. |
| **Visualise** | To imagine how something will look once it has been completed. |
| **Wide angle lens** | A lens with an angle of view greater than 60°. Used when the photographer is unable to move further away or wishes to move closer to create steep perspective. |
| **X** | Synchronisation setting for electronic flash. |
| **X-sync** | A socket on the camera or flash unit which enables a sync lead to be attached. When this lead is connected the flash will fire in synchronisation with the shutter opening. |
| **Zoom lens** | A lens which can vary its focal length. It is possible to have a wide angle zoom lens, a wide angle to telephoto zoom that covers the standard focal length and a telephoto zoom lens. The drawback of these lenses is that they have relatively small maximum apertures e.g. f4 or f5.6 whereas a fixed focal length lens may have an aperture of f2 or f2.8. |
| **Zooming** | This is a technique where the focal length of a zoom lens is altered during a long exposure. The effect creates movement blur which radiates from the centre of the image. |
| **Zone** | A tone within the scene or image that is one stop (twice as dark or light) from the next. |
| **Zone placement** | The placing of a specific subject tone to a specific tone in the final image. |

# Other Titles in the Series

## Studio Photography: Essential Skills

*John Child*

This provides essential skills for photographers with medium and large format cameras working with tungsten and flash in a controlled environment. The photographer is guided through the use of studio equipment for a variety of different purposes. With a strong commercial orientation, the emphasis is placed on technique, communication and design within the genres of still life, advertising illustration, portraiture and fashion.

1999 • 160 pp • 246x189 mm • Paperback • 0 240 51550 1

## Photographic Lighting: Essential Skills

*John Child and Mark Galer*

This covers information that is essential for photographers to understand when working with light.
Through a series of practical exercises, the student photographer is shown how to overcome the limitations of equipment and film emulsion, to achieve creative and professional results. With theory kept to a minimum, this book shows how to tackle difficult lighting conditions and manipulate light for mood and atmosphere using basic and advanced metering techniques.

1999 • 160 pp • 246x189 mm • Paperback • 0 240 51549 8

**To order your copies call (01865) 888180 (UK)
or 1-800-366-2665 (US)
or visit our web site on http://www.focalpress.com**

# Basic Photography
## *Michael Langford*

*Basic Photography* is an international bestseller with a long established reputation as the introductory textbook for photography. Initially published over thirty years ago the book has been re-written and revised regularly, and translated into four foreign language editions. It remains a classic reference source for students and newcomers to photography of all ages.

1997 • 320pp • 246 x 189 mm • Paperback • 0 240 51485 8

# Advanced Photography
## *Michael Langford*

This is a practical book for students and serious enthusiasts who wish to achieve more professional looking results. From choosing lenses and camera equipment, to film types and technical data, lighting and tone control, processing management and colour printing; the book offers technical solutions and practical advice on all aspects of professional photography. It includes not just the latest camera equipment and films, but explains how new digital methods can be used alongside silver halide systems – allowing the reader to benefit from the best practical features of each.

1998 • 320pp • 246 x 189 mm • Paperback • 0 240 51486 6

**To order your copies call (01865) 888180 (UK)
or 1-800-366-2665 (US)
or visit our web site on http://www.focalpress.com**

# Professional Photography Series

## Professional Architectural Photography
*Michael Harris*

As a perfectionist art form, architectural photography is a methodical process demanding patience and clinical precision from its practitioners, combined with an experienced understanding of the potential and effects of natural light. Packed with detailed information plus first-hand tips and advice, this is a complete introduction for any aspiring architectural photographer, or a practicing professional needing to brush up on skill and knowledge.

1998  •  192pp  •  246 x 189 mm  •  Paperback  •  0 240 51532 3

## Professional Interior Photography
*Michael Harris*

*Professional Interior Photography* is a complete guide to the practice and art of the interior photographer. It guides you through the vast choice of equipment and materials available, combines the theory of lighting and composition with practical tips and suggestions for overcoming day-to-day problems, and offers useful advice on presenting and storing images, business skills and administration.

1998  •  192pp  •  246 x 189 mm  •  Paperback  •  0 240 51475 0

# Starting Photography
*Michael Langford*

This is a practical book for the absolute beginner. It shows you how to compose your pictures for more visual effect, understand the camera controls that will allow you more creative freedom, tackle different subjects and difficult lighting conditions, photograph in a studio and process and print your own pictures in the darkroom. Each chapter is fully illustrated with colour examples and suggestions for practical exercises allow you to practice and explore different effects.

1999  •  192pp  •  234 x 156 mm  •  Paperback  •  0 240 51484 X

# Story of Photography
*Michael Langford*

From works of art to hard-hitting photojournalism, photography continues to challenge and enhance our perception of the world. This book shows how it became possible: from the early experiments with light, to sophisticated camera equipment and the stunning work of famous photographers. Illustrated throughout, the reader is taken on a fascinating photographic tour through history, whether you are a student or dedicated enthusiast, this book will further your understanding of photography.

1998  •  224pp  •  246 x 189 mm  •  Paperback  •  0 240 51483 1

# Professional Photography Series

## Professional Press, Editorial and PR Photography
### Jon Tarrant

Editorial, press and PR photographers need to be able to take a range of interesting and informative photographs. Success requires not just individual flair and skill, but an ability to market those talents in order to win space in publications. This book is packed with hints, tips and first-hand advice on the day-to-day running of a business, the equipment you need and how to organise your finances. Advice on the best way to present your portfolio and how to deal with clients and work to a brief is also given.

1998  •  192pp  •  246 x 189 mm  •  Paperback  •  0 240 51520 X

## Professional Nature Photography
### Nigel Hicks

Based on the author's own experience of running a successful nature photography business, this book offers a unique insight into the essential tools and techniques: from the equipment you need, to researching and finding new clients, negotiating contracts, managing finance, working to a brief and an understanding of professional ethics. It also includes an overview of specialist skills, such as how to read difficult lighting conditions, shooting from a hide, stalking animals, photographing captive animals, photographing plants and underwater photography.

1999  •  192pp  •  246 x 189 mm  •  Paperback  •  0 240 51521 8

---

**To order your copies call (01865) 888180 (UK)
or 1-800-366-2665 (US)
or visit our web site on http://www.focalpress.com**

# Adobe Photoshop 5.0 for Photographers
*Martin Evening*

This classic reference source deals directly with the needs of photographers. Whether you are an accomplished user or are just starting out, this book contains a wealth of practical advice, hints and tips to help you achieve professional looking results.

Included is a free tutorial CD-ROM with full multimedia walkthrough movies of the techniques described in the book. A unique interactive filter section allows you to try out the effects of different filters, and free tryout software includes a digital watermarking system that helps protect your images.

1998  •  320pp  •  246 x 189 mm  •  Paperback  •  0 240 51519 6

# Digital Imaging for Photographers
*Adrian Davies and Phil Fenessy*

This is a complete introduction to digital imaging for photographers.

From image capture through to manipulation and output, the book takes you step by step through the processes involved in digital imaging. Everything you need to know is here: the necessary hardware and software involved, an overview of digital cameras on offer, film scanners, storing and compressing files, the "digital darkroom", image processing with examples from Adobe Photoshop, colour management techniques, output issues, transmitting images over the web and a whole lot more!

1998  •  192pp  •  246 x 189 mm  •  Paperback  •  0 240 51538 2